IMAGES
of America

BORING

IMAGES
of America

BORING

for all the (NOT) Boring Times

Dan Bosserman

Dan Bosserman (signature)

ARCADIA
PUBLISHING

Published by Arcadia Publishing
Charleston, South Carolina

Printed in the United States of America

Library of Congress Control Number: 2014930608

For all general information, please contact Arcadia Publishing:
Telephone 843-853-2070
Fax 843-853-0044
E-mail sales@arcadiapublishing.com
For customer service and orders:
Toll-Free 1-888-313-2665

Visit us on the Internet at www.arcadiapublishing.com

*To Shirley Boring Crow, whose devotion to the memory of
her family and Boring's history has meant so much*

CONTENTS

ACKNOWLEDGMENTS

This book would not have been attempted had it not been for the ongoing efforts of three Boring notables who are no longer with us. Miles Aubin and Delmar Bakke were the unofficial historians of Boring for decades, and their work has been invaluable. Philip Jonsrud was associated more with Sandy, but his ancestors first settled in Kelso, and his works in history are legendary in our region. All three are sorely missed by everyone in the community.

The Sandy Historical Society has been the collector and guardian of the history of the Sandy area—including Boring, eight miles down the road—since 1926. Its current home, the Sandy Historical Museum, opened in 2007 with focus on the Barlow Road, covering Government Camp to Eagle Creek, the logging industry, and the founding families, all depicted through written history panels and artifacts of the time. The museum library is a peaceful place to sit, read, and learn. It is impossible to thank all of those volunteers individually, but without their hard work and their love of local history, this book would not have been possible.

Special thanks go to Kaye Wright, Nancy Spencer, and Michael Maund for helping with photograph scanning and restoration and special photography projects. Robert and Glenda Boring and Shirley Boring Crow have a family interest, of course, but their aid has been above and beyond any reasonable expectation. James Valberg, Jean Rolli, Kathryn Bigelow, Linda Parker, and Janet Karlen Edmondson have been an immense aid to this project.

I would especially like to thank Nancy Hoffman for helping me start out in the writing business nearly 20 years ago and inspiring me all these years, and particular thanks are due to my acquisitions editor at Arcadia Publishing, Rebecca Coffey, for her expert guidance (when requested) and prodding (when needed).

Finally, to my wife, Kathleen, thank you for your love and encouragement, not only in this venture but also in all of our life's struggles and joys.

Unless otherwise noted, all images are courtesy of Sandy Historical Society.

INTRODUCTION

Dominating the landscape east of Portland, Oregon, and for 50 miles in every direction, is Mount Hood, 11,249 feet high. Its Multnomah Indian name is Wy'east, and there are various legends about how the mountain came to be. In one version, the two sons of the Great Spirit Sahale fell in love with the beautiful maiden Loowit, who could not decide which to choose. The two braves, Wy'east and Klickitat, burned forests and villages in their battle over her. Their great anger led to their transformation into volcanoes.

Their battle is said to have destroyed the Bridge of the Gods and thus created the great Cascades Rapids of the Columbia River. Sahale became enraged and smote the three lovers. Seeing what he had done, he erected three symbolic mountain peaks to mark where each had fallen. He made beautiful Mount St. Helens for Loowit, proud and erect Mount Hood for Wy'east, and the somber Mount Adams for Klickitat, as if still mourning the loss of Loowit.

The mountain was given its present name in 1792 by Lt. William Broughton, a member of Capt. George Vancouver's discovery expedition, in honor of Lord Samuel Hood, a British admiral at the Battle of the Chesapeake. Lieutenant Broughton observed its peak from Belle Vue Point at what is now called Sauvie Island during his travels up the Columbia River, writing, "A very high, snowy mountain now appeared rising beautifully conspicuous in the midst of an extensive tract of low or moderately elevated land." (This was the location of today's Vancouver, Washington.)

The Portland metropolitan area, including suburbs, is one of the few places in the continental United States to have extinct volcanoes within a city's limits. Boring itself lies at the base of one of these lava domes, and the generic term for at least 32 cinder cones and small shield volcanoes lying within a 13-mile radius is Boring Lava Field.

When the first of the Boring family came to the farming community, they little suspected that a broad geologic phenomenon stretching from Oregon to Washington across the Columbia River would also eventually bear their name.

The Boring Lava Field is an extinct Plio-Pleistocene volcanic field zone. The tiny, unincorporated town of Boring lies just to the southeast of the densest cluster of lava vents, which became active at least 2.7 million years ago and have been extinct for about 300,000 years. But what gave the area its distinct character—particularly its rolling hills, fish-filled streams, and fertile valleys—was the Missoula Flood at the end of the last glacial period around 15,000 years ago, when giant Lake Missoula in western Montana burst through an ice dam, sending a torrent of water that tossed boulders and ripped off cliff faces down the Columbia River and the Willamette Valley. Every few decades for several hundred years, the lake refilled until it pushed through again.

Scientists believe it was about this time that a land bridge connecting Alaska and Russia across what is now the Bering Strait sank into the sea; sometime before that, the first humans came to this continent, quickly spreading all across and down to South America. Why did the migrants come in the first place? Perhaps it was to follow herds of bison or other game that were migrating across the land bridge. Perhaps it was because of some change in living conditions on the Asian

side of the bridge. Perhaps they thought the grass was greener on the other side of the Bering Strait. Nobody knows. Nor do we know if the wanderers spent years living on the land bridge, if they crossed in one quick motion, or if the migration comprised several distinct movements.

And we do not know yet if the original Americans used boats to cruise the Pacific coast to South America, where archeological sites are nearly as old as those in Alaska. There is now evidence that an ice shelf at the south of the land bridge may have been an ideal place for migrating, since the migrants would have had access to sea mammals and fish as they moved. Some scientists speculate that the first people of the Americas might have come by sea, having been blown off course by storms, since some human artifacts in eastern Oregon and South America seem to predate the end of the land bridge across the Bering Strait.

In any case, they quickly (in geological time) spread throughout North and South America and were the only occupants for some 12,000 years before European navigators "discovered the New World." The first Europeans to see the Oregon coast were Spanish sailors in the mid-16th century, who produced rough maps describing the area. In 1579, English seaman Francis Drake, in quest of Spanish loot and the Northwest Passage in his *Golden Hind,* anchored in an inlet north of the Golden Gate and took possession of a portion of the Pacific coast for Queen Elizabeth I. In 1778, the English sea captain James Cook visited and traded in Oregon.

In 1787, Boston merchants sent Robert Gray to the Oregon Country. On his second voyage, in 1792, Gray sailed over the bar of the Columbia River and named it for his ship, the *Columbia.* This was the first American claim to the Pacific Northwest by right of discovery. With the Louisiana Purchase and the Lewis and Clark Expedition in 1803, the Oregon Country's destiny was inextricably joined to that of the United States.

The Oregon Trail began as an unconnected series of trails used by Native Americans. Fur traders expanded the route to transport pelts to trading posts and rendezvous. In the 1830s, missionaries followed the still-faint trail along the Platte and Snake Rivers to establish church connections in the Northwest. A combination of economic and political events in the 1840s converged to start a large-scale migration west on what was then known as "the Oregon Road."

That migration continued in mass numbers at least until 1853, the year Joseph Boring arrived and soon settled in a little valley that would one day be called by his name.

One

FIRST IMMIGRANTS TO OREGON

Neither the pioneers nor the fur trappers were the first to come to the Oregon Country. At least 10,000 years ago, immigrants from Asia probably came across a land bridge over the Bering Strait. Archeologists have long believed this was the beginning of the Native American habitation of the Americas.

The Clackamas Indians are a tribe of Native Americans of the state of Oregon who traditionally lived along the Clackamas River in the Willamette Valley. Lewis and Clark estimated their population at 1,800 in 1806. At the time, the tribe lived in 11 villages and subsisted on fish, berries, and roots. Like others of the Chinookan tribes, they practiced head flattening. From infancy, the head was compressed between boards, thus sloping the forehead backward. They are the technical owners of the Willamette Meteorite.

The now-extinct language spoken by the Clackamas Tribe is also known as Clackamas; it is one of the Chinookan languages, specifically a variety of Upper Chinook. It is closely related to the still-living (but highly endangered) Wasco-Wishram language, another variety of Upper Chinook.

As land along the Willamette River became scarcer, settlers started homesteading along the valleys of rivers near the Willamette. Although details of Native Americans in the area are not well recorded, evidence in the form of artifacts and settlement reports exist. What is known is mostly about the Clackamas tribe, who frequented the area around the Clackamas River and its tributaries. One of these was Deep Creek, which flows through the center of Boring Junction and once was a spawning ground for many salmon.

The Clackamas Tribe had a permanent camp at Willamette Falls in present-day Oregon City, a few miles downstream from Boring. Influenza, skirmishes with each other and with whites, and increasing encroachment by white settlers eventually forced the Native Americans either to reservations or into the cities. By 1855, the 88 surviving members of the tribe were relocated to Grand Ronde, Oregon. They first lived on the Grand Ronde Indian Reservation but later blended into the general population. Descendants of the Clackamas belong to the Confederated Tribes of the Grand Ronde Community of Oregon.

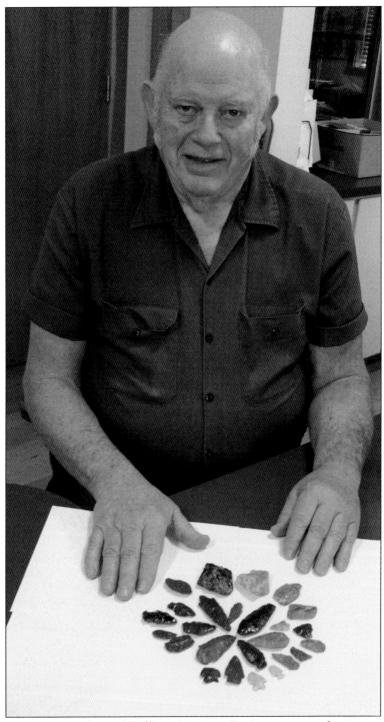

Robert Boring, great-grandson of William Harrison Boring, grew up plowing, mowing, and exploring the farm homesteaded by his forebears, always on the lookout for Indian artifacts. Often, he would spot an odd-looking stone and examine it, looking for more examples close by. (Courtesy of Robert Boring.)

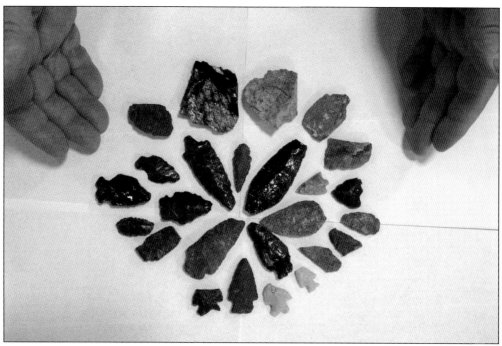

Because there were apparently no permanent settlements of Native Americans in the area, the artifacts found are relics of people passing through from one part of the country to another. Willamette Falls, not far downstream from Boring, was a popular gathering and trading place for many tribes from all over the Northwest. (Courtesy of Robert Boring.)

The round artifact on the left, made from the tip of a horn, is thought to have been fashioned as a spoon or ladle. The object on the right was first thought, because of its shape, to be a form for a moccasin, but a Native American visitor declared it to be a knapping tool, used for shaping arrowheads and spear points.

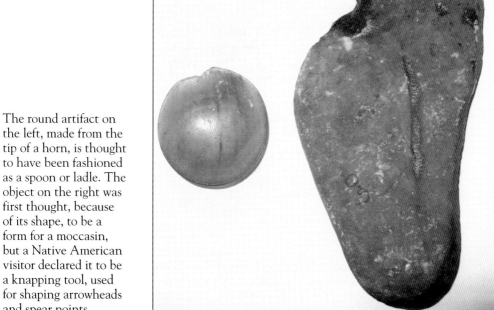

An assortment of larger tools found at various camping grounds shows the variety of methods the early tribes had for preparing food, equipment, and even other equipment. The flat-sided stones were used for grinding and smoothing, while the flaked ones were useful for preparing meats, hides, and bark.

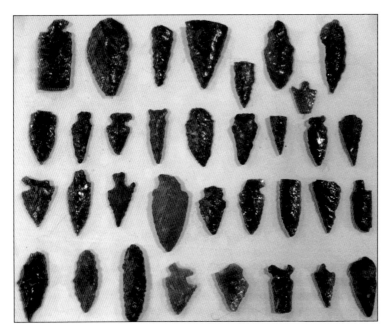

Every arrowhead has a type name, according to the type or category it falls into. Arrowhead type names are usually, but not always, assigned from the location where the very first type was discovered—*Clovis* from Clovis, New Mexico; *Cumberland* for the Cumberland River in Tennessee; *Folsom* from Folsom, New Mexico.

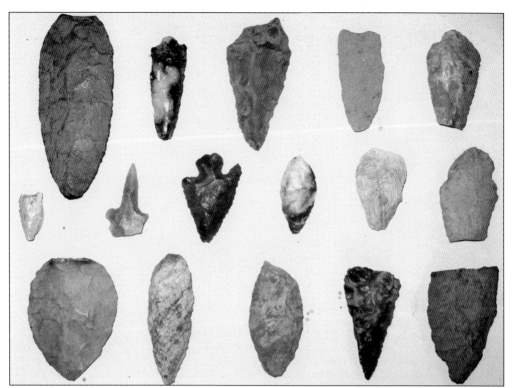

Native Americans were great recyclers of stone implements, usually wasting nothing of the material often quarried from as far away as 200 miles. Arrowheads that became misshapen through breakage or resharpening were often adapted into a completely different tool, such as a knife or a drill. Sometimes, older cultures' stone implements were found and reshaped or recycled for use by later cultures.

Arrowhead types are identified first by the shape of the base, but other factors play a role in typing an arrowhead as well. These include the overall shape of the arrowhead, the flaking style, whether or not the arrowhead is fluted, and the material it is made from.

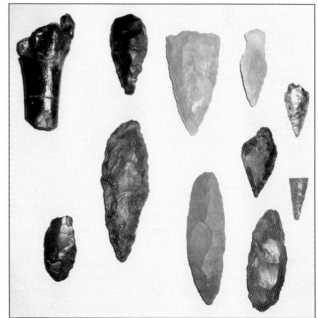

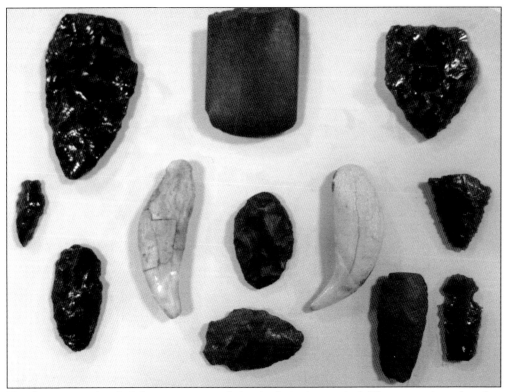

Notches in arrowheads did not appear until the Archaic time period. These were introduced as a better method of hafting the points to a wooden shaft. Animal-sinew and plant-fiber bindings were used, and asphaltum or pine tree pitch was added as a form of glue to join the arrowhead or knife to its handle.

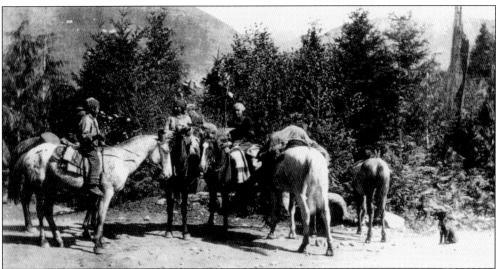

As late as 1932, Native Americans would cross the Cascade Range of mountains to participate in salmon festivals and huckleberry harvests. Each year, We Love Clean Rivers sponsors the Willamette Falls Festival, featuring foods common to natives of the Northwest prepared by chef Matt Bennett and the Confederated Tribes of Grand Ronde.

Two

WHY CALL IT BORING?

The Boring family was certainly not the first to come to the area that now bears their name, although Joseph and Sarah Boring did both come across the Great Plains in wagons drawn by oxen in 1853, perhaps on the same wagon train. They married in Oregon in 1859. They were not the most prolific or the most businesslike family, so it is easy to wonder how the place came to be called Boring. It was probably because Joseph's younger brother, William Harrison Boring, donated the land to build the first school, and it was named after him, setting in motion a series of events that led to virtually everything in the area being referred to as Boring (not *boring*).

In 1874, the United States was going through the period of Reconstruction after the Civil War. Political controversy of the day centered on the question of whether freed slaves and white landowners could live together, but the Long Depression from 1873 to 1879 brought economics to the forefront. Wounded in the throat at the Battle of Vicksburg and discharged from the 1st Illinois Volunteers, William Boring had returned to his home in Greenfield, Illinois, to continue working on his mother's farm, and had married Sarah Wilder in 1867. In 1874, President Grant was offering free land in the West to veterans who would homestead the property for two years. Five years before, in 1869, the national railroad system had been completed, and it was now actually possible to travel "from sea to shining sea" in relative comfort.

At the respective ages of 33 and 31, the Borings boarded a train for San Francisco and then traveled to Portland, Oregon, aboard a ship. They arrived at their claim 25 miles east of Portland in June 1874, and they probably lived with William's half brother Joseph until they built their own house. In October 1875, a daughter, Elsie, was born to William and Sarah, but she lived for only nine days. Orville Wilder Boring was born April 26, 1879, and each generation of Borings has taken an active part in the community to this day, encouraging and supporting education, commerce, faith, and civic responsibility.

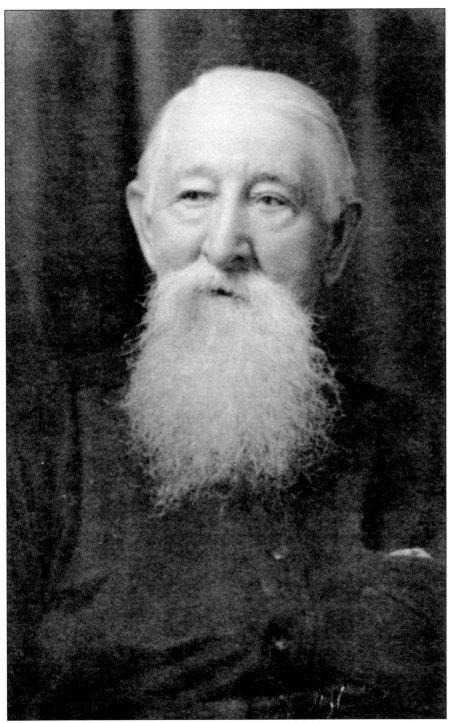

Joseph Boring was born in Macoupin County, Illinois, in 1829. He came across the Oregon Trail in a covered wagon drawn by an oxteam in 1853 and eventually took out a Donation Land Claim just south of what is now the Mountain View Golf Course. He and Sarah Hougland were married in 1859. (Courtesy of Robert Boring.)

Born in Greenfield, Illinois, in 1841, Joseph's half brother William fought for the Union in the Civil War. This photograph would have been made just before or during the war, as it shows him clean-shaven. He received a wound in the face during battle and afterward always wore a beard to hide the scar. (Courtesy of Robert Boring.)

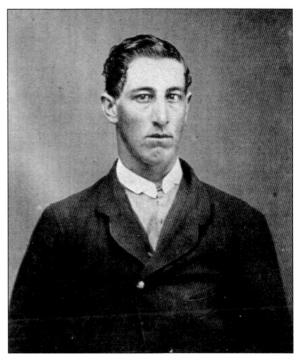

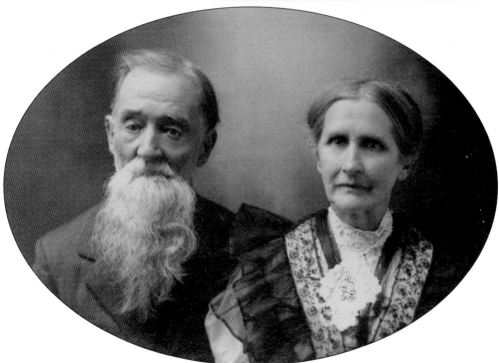

Joseph and Sarah Boring were well settled on their claim by the time William and Sarah Boring immigrated 21 years later. They no doubt shared living quarters until the younger Borings could clear some land, build a home of their own, and begin "proving up" their claim. (Courtesy of Robert Boring.)

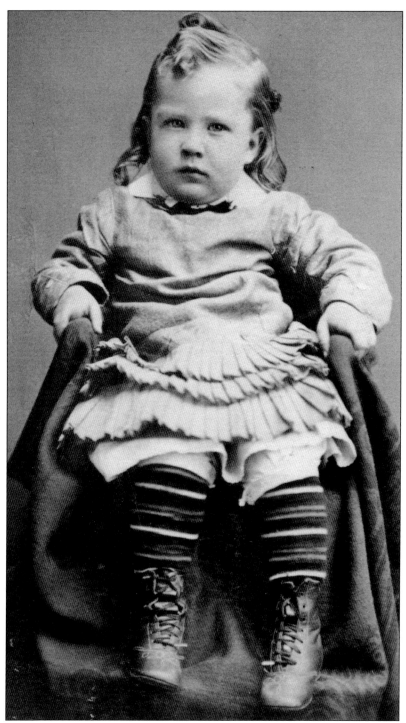

Born in 1879, Orville Wilder Boring grew up with the little community that would bear his family's name, watching it develop from a tiny settlement to a busy logging town and then to a local transportation hub. He would witness the country enduring the Spanish-American War, World Wars I and II, the Great Depression, and the Korean War. (Courtesy of Robert Boring.)

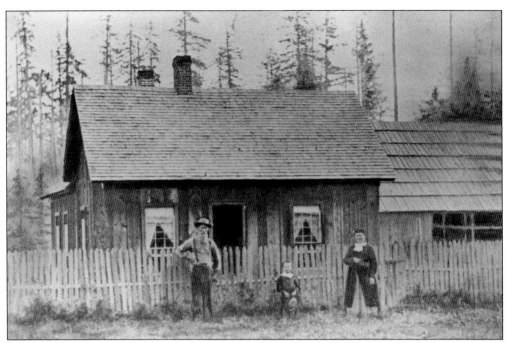

The original William Boring homestead house was a small but sturdy structure, adequate for William, Sarah, and their son, Orville, shown here in 1884 at five years old. William liked to hunt and once tangled with a bear in the Deep Creek canyon. Evidently, William won the battle. (Courtesy of Robert Boring.)

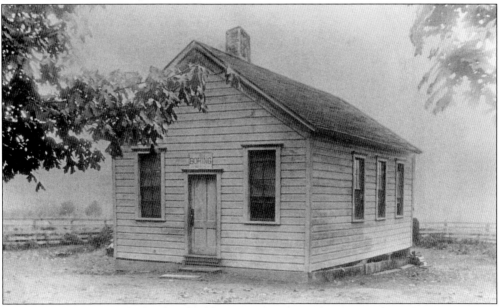

The Borings donated the land to build the first Boring School, constructed in 1883. It was later incorporated as a wing to the larger Boring farmhouse after the new Boring Grade School (briefly known as Oregonia) was built. Five maple trees were planted about the same time that the original school was built and became the reason for naming the Borings' home Maple Shade Farm. (Courtesy of Robert Boring.)

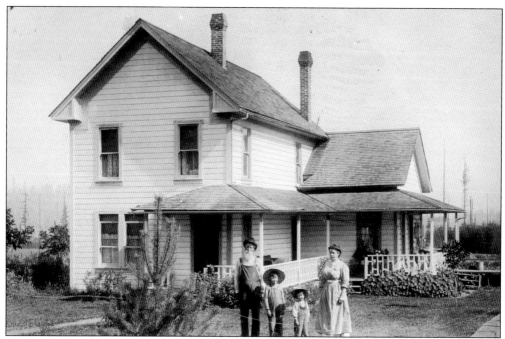

This house, built in 1904, was spacious compared to the old one. Orville had grown up and married Lucy Perret by this time; she is shown here with William and his grandsons Lester and Willard, born in 1906 and 1910 respectively. Both were born in the section of the house (on the right) that had been the original Boring School. (Courtesy of Robert Boring.)

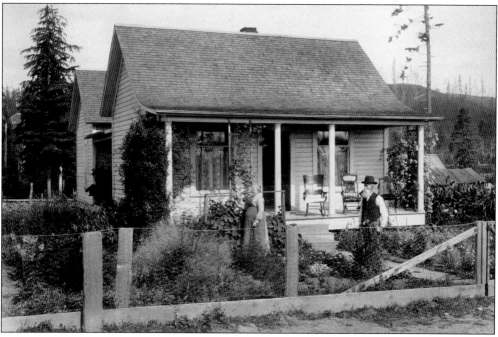

William and Sarah Boring lived in this house on Richey Road in 1915. Sarah was known for her love of flowers. The center chair on the front porch remains in the family. In a letter still kept by Boring descendants, Sarah describes herself as "becoming fleshy." (Courtesy of Robert Boring.)

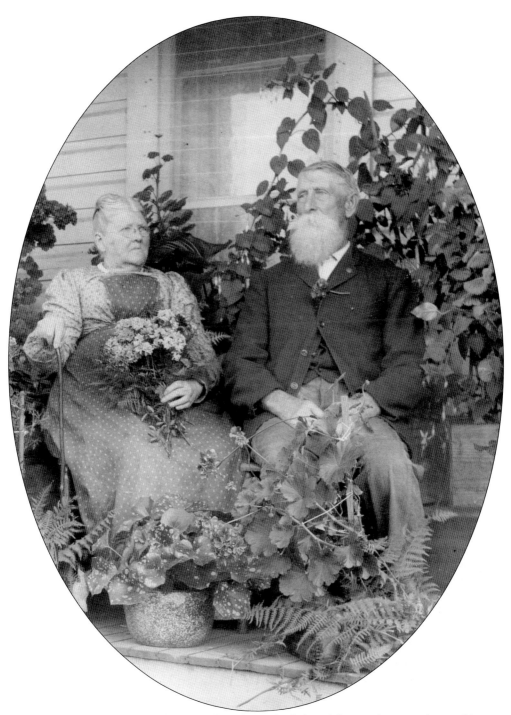

William and Sarah sit on the front porch with Sarah's beloved flowers, happy to live and love in retirement after Orville was grown. They lived in comfort in their two-story home, with three bedrooms upstairs, a parlor, a kitchen and pantry, and a mudroom. "But it was still four bedrooms and a path to the outhouse, not four rooms and a bath," wrote Shirley Boring Crow, their great-granddaughter. (Courtesy of Robert Boring.)

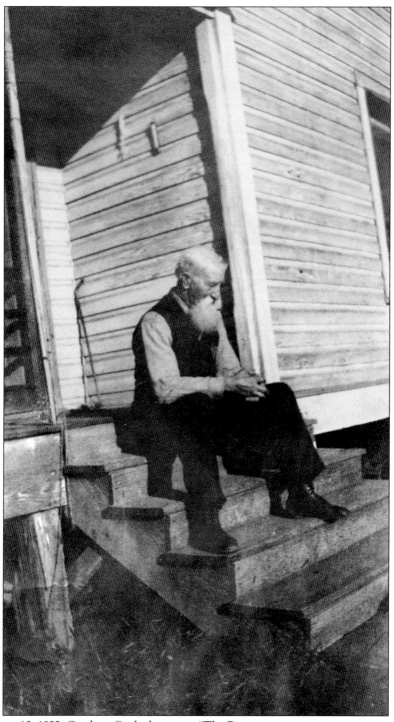

The February 12, 1922, *Gresham Outlook* reports, "The Boring community is mourning the recent death of Mrs. Sarah Boring. She is survived by her husband, Mr. W.H. Boring, a son Orville, and grandsons Lester and Willard Boring." After Sarah passed on, William Boring lived alone in this house until his death in 1932 at the age of 91. (Courtesy of Robert Boring.)

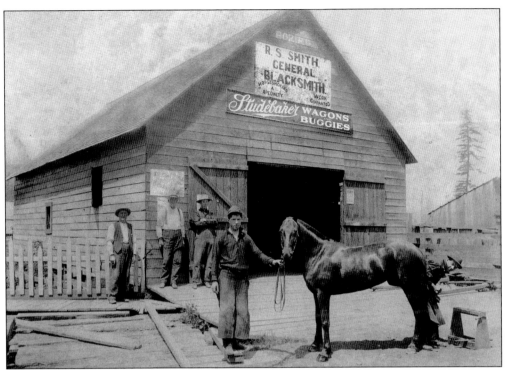

Since the train station, the post office, and the school were referred to as Boring, local businesses like this blacksmith shop and Studebaker wagon sales agency took up the name. In 1909, R.S. Smith moved to Sandy and very quickly began selling Studebaker automobiles. (Courtesy of Robert Boring.)

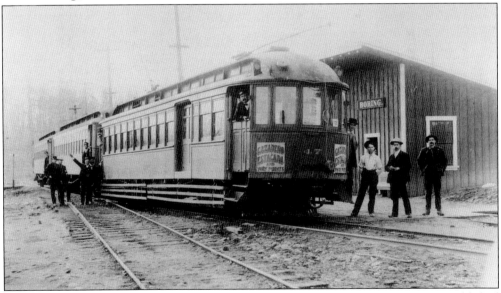

In 1903, the town of Boring Junction was envisioned and platted. A post office was established and was known as Boring. In every official communication, the community was known as Boring, so whether or not it would ever become an incorporated city, it had been recognized as Boring all over the county.

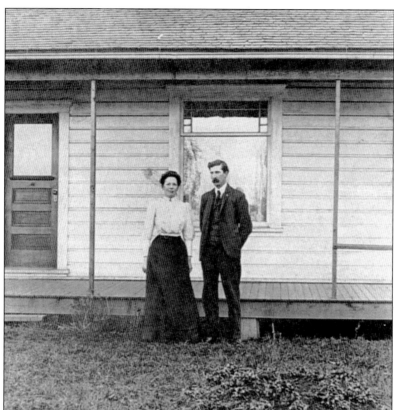

In 1905, when Orville was 26 and Lucy Ida Perrett was 18, they were married and moved into the main farmhouse. Orville had dreamed of being a teacher, but migraine headaches forced him to give up his goal. He worked hard on the farm and brought up his family to believe in strict moral principles. (Courtesy of Robert Boring.)

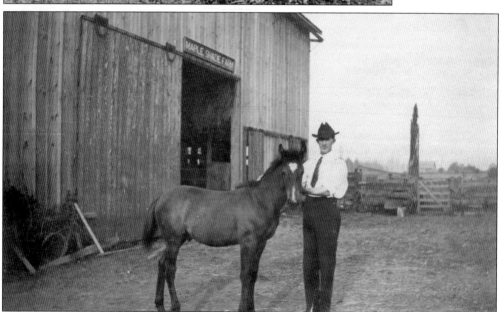

After Orville had given up his dream of being a teacher, he devoted himself to his family, his farm, and his faith. He worked in the woods, in sawmills, and in the shipyards. Later, in keeping with his commitment to education, he worked as the clerk of the school district for 18 years. (Courtesy of Robert Boring.)

Willard was born to Orville and Lucy on Halloween night in 1910. He is shown here with the beginning of his lifelong obsession with collecting bells. In his lifetime, he collected over 200 bells of every description, including cowbells from his own farm and some that he brought back from a journey to Switzerland. (Courtesy of Robert Boring.)

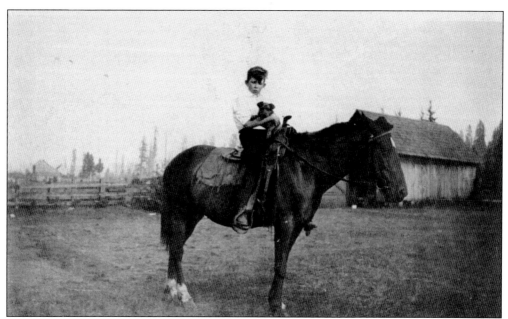

Dressed in white shirt and knickers, Willard went riding—evidently on Sunday—to demonstrate how manageable his horse could be, even while carrying a boy with a puppy on its back. Orville Willard (most often called "Bill") and his older brother, Lester, were almost always photographed while dressed in their Sunday best, even on trips to the zoo. (Courtesy of Robert Boring.)

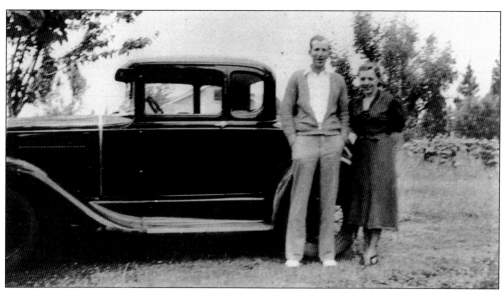

While they were courting, Willard and Frances Boring found a Ford Model A more comfortable and convenient than riding horseback. They were married November 12, 1938, after a four-year courtship, begun the day Frances Marie Adair arrived in Oregon from Hayden, Colorado. In 1940, when their son Robert was born, they moved back to help Orville and Lucy on the farm. (Courtesy of Robert Boring.)

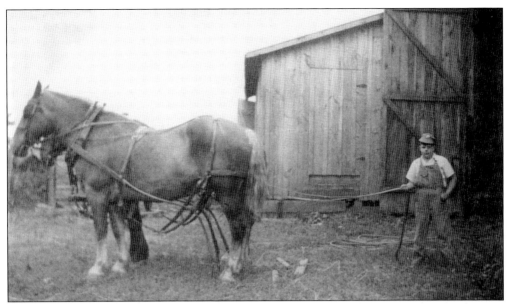

As a 10-year-old in 1950, Robert Boring had already become a fair hand with a team of horses on the farm his great-grandfather William had homesteaded. The responsibility of doing chores in the barn made him feel grown-up, and when the new tractor came in 1948, he was thrilled. (Courtesy of Robert Boring.)

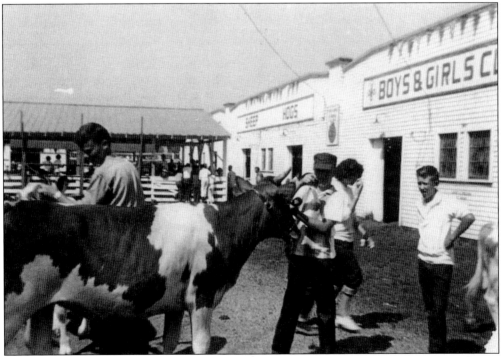

James was the youngest of the three children of Willard and Frances Boring, and he followed the family tradition of farming the land. Here, he is shown with only one of a long series of first-prize blue ribbons won at the Clackamas County Fair, which he won showing one of the cows he raised.

27

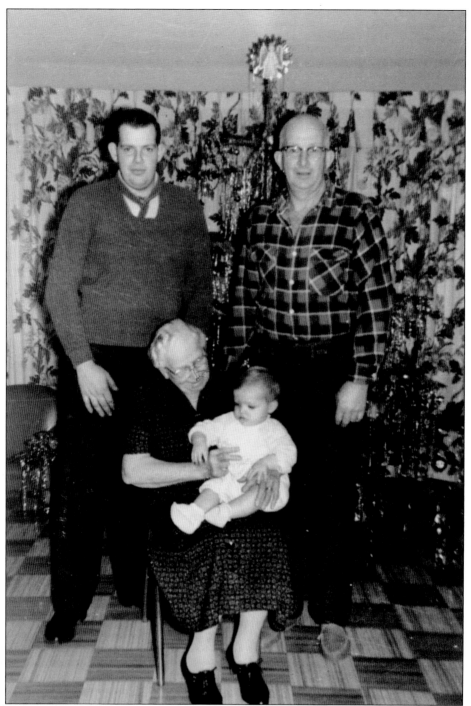

Robert Boring grew up and married Glenda Lockling, his high school sweetheart. They had two sons, Darrell and Michael. Shown here are four generations of Borings—Lucy, Willard, Robert, and Darrell—at Christmas 1961. Darrell has since grown up and had two children, Emily and Nicholas. Willard is the only person to have known six generations of Borings that lived on the farm. (Courtesy of Robert Boring.)

Three

CIVILIZATION BEGINS WITH FARMING

The first settlers came to farm the land. The provisional government formed at Champoeg had limited the land claims offered in the hope of preventing land speculation. The Organic Act of the Oregon Territory had granted 640 acres to each married couple. The Donation Land Claim Act of 1850 voided the previous statutes but essentially continued the same policy and was worded in such a way as to legitimize existing claims.

One such claim legitimized by the act was that of George Abernethy, who had been elected to the governorship in the days of the provisional government. His claim became famous for Abernethy Green, where new immigrants camped at the end of the Oregon Trail while seeking a piece of land for themselves.

The law, a forerunner of the later Homestead Act, brought thousands of white settlers into the new territory, swelling the ranks of travelers along the Oregon Trail. Nearly 7,500 land patents were issued under the law, which expired in late 1855. It was during this time that Joseph Boring crossed the plains and settled south of what became known as Boring Junction.

Though logging, manufacturing, and other industries would eventually become vital parts of the economy, the first priority after shelter was a sustainable food supply. The land was covered with timber, making shelter readily available, but it had to be cleared in order to plant crops and supply food for the coming years. Farming and logging, then, supported each other. Farmers needed cleared land; loggers and mill workers needed food supplies.

Of necessity, the first farms had to provide the day-to-day needs of the homesteaders themselves, but it soon became possible and profitable to specialize in order to provide produce for the growing population in nearby Oregon City and, increasingly, in Portland. As soon as there was a large enough market for grain, vegetables, meat, and dairy products, Boring saw the need to become a transportation center and marketplace. No doubt Joseph Boring was in communication with his brother William, who was eligible for the Homestead Act of 1862. William and Sarah Boring came to Oregon in 1874, filed their claim, and started farming.

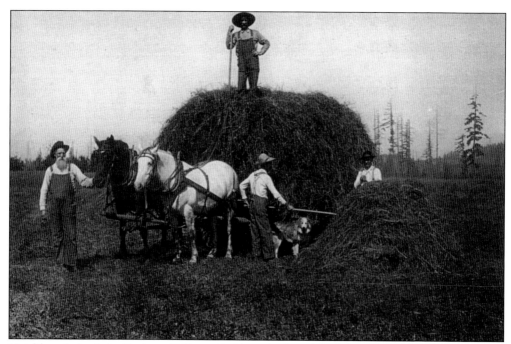

Neighbors helped the Borings, William (holding the horse) and Orville (on top of the load), to get in hay for the winter. With no balers, tractors, or other equipment, farming was incredibly labor-intensive, and hay was gathered by hand and stored loose in large barns. (Courtesy of Robert Boring.)

Torkel Jonsrud was born in Norway in 1835 and came with his parents and five brothers to Minnesota in 1854. He served as an officer in the Union army during the Civil War and, later, as a Minnesota state senator. He came to Oregon in 1876 with his wife, Kari, and five children, building this house in Kelso in 1877.

30

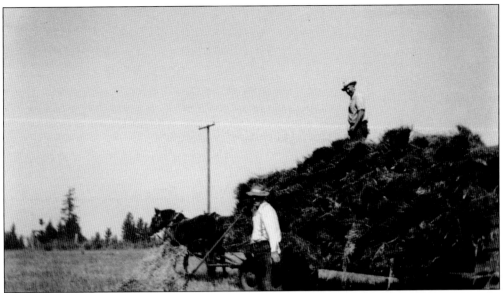

Willard Boring (on the ground), William's grandson, and Norman Hulick are bringing in the sheaves on September 6, 1953, using horses to pull the wagon. The sheaves of grain were to be transported to the threshing machine, where the wheat could be separated from the straw and chaff, which could then be used for bedding or mulch. (Courtesy of Janet Karlen Edmondson.)

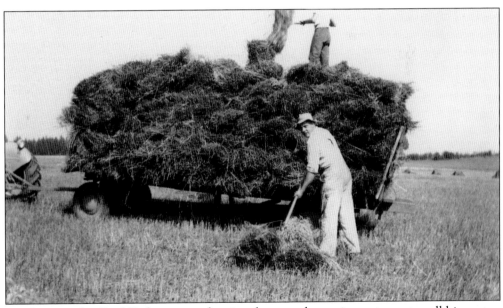

On the same day, Emil Karlen was performing the same duty, using a tractor to pull his wagon. A friendly competition ensued to find out which method was more effective. By all accounts, the result was a draw, though there was still a question as to whether the horses or the tractor cost more to fuel. (Courtesy of Janet Karlen Edmondson.)

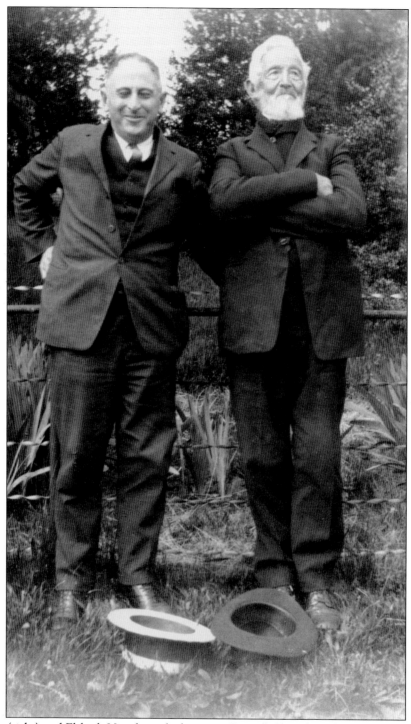

Matheus (right) and Elsbeth Vetsch, with their sons Peter (left) and Andreas, came to America in 1878 and paid Joseph Boring for 160 acres and a house on what is now Kelso Road, south of Boring. Over the next few years, they purchased 200 more acres, including part of what is now the Mountain View Golf Course. (Courtesy of Janet Karlen Edmondson.)

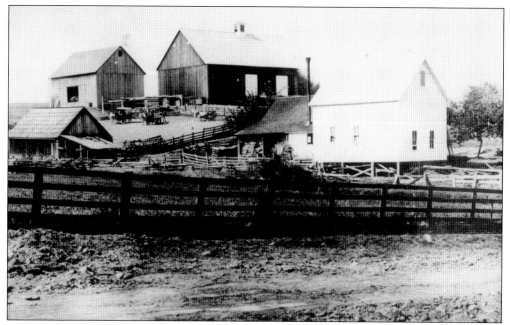

In 1882, Matheus constructed a building on the farm and began to make processed butter. Miles Aubin reported on May 2, 1897, that "Mr. Vetsch, our enterprising creamery man, is buying milk from farmers in this community and for several miles around." The Vetsch farm is shown here before it burned in 1917. (Courtesy of Janet Karlen Edmondson.)

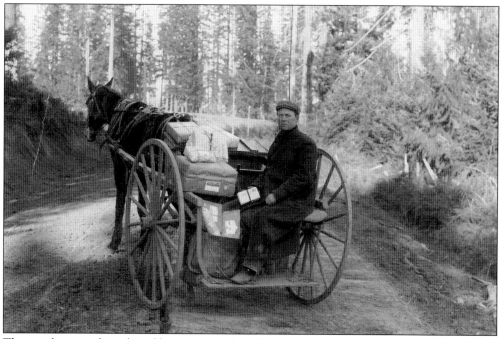

The population and number of farms increased, and the railroad brought mail more often. Individual mail delivery was considered necessary, and Frank Childs was one of the earliest letter carriers, with rudimentary transportation in every kind of weather. It was not quite the Pony Express or Western Union, but it met early settlers' needs for communication.

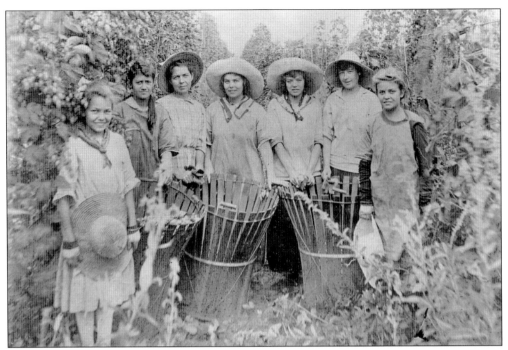

The Willamette Valley's climate and soil were ideal for growing hops, especially in the Oregon City and Woodburn areas. During the picking season, whole families would travel to Woodburn or Oregon City to help harvest the crop. Hops are used primarily as a flavoring and stability agent in beer.

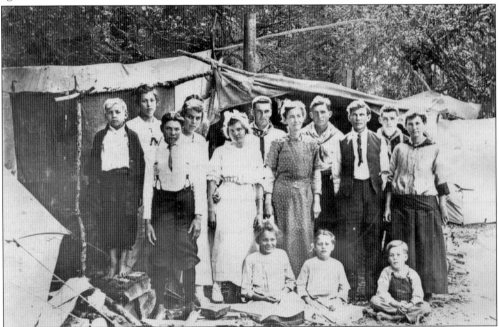

In 1918, the Dodd, Frank, and Hickey families camped near the hop fields to avoid commuting. They named their hastily built shelter the "Hop-Inn." Though mostly used to give beer a bitter, tangy flavor, hops were also used for various purposes in other beverages and herbal medicines.

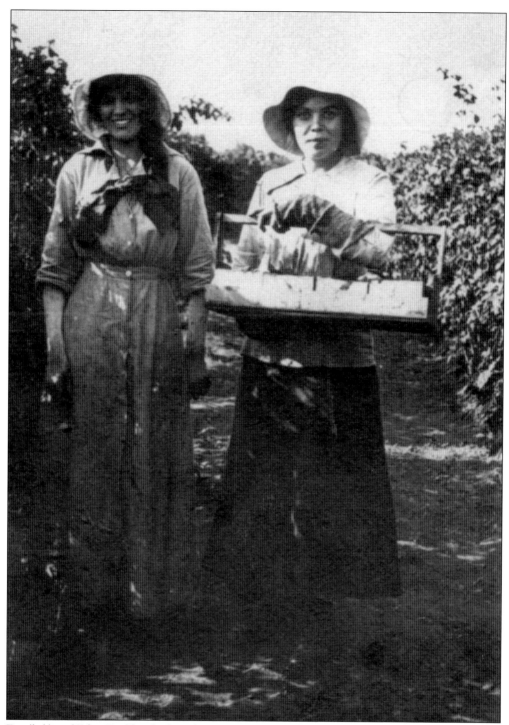

Eva (left) and Edna Dodd picked raspberries in the early 1920s. Instructions for picking raspberries were, as quoted by Miles Aubin from instructions issued by the cannery, "(1) Do not call pickers too soon, as pickers might get discouraged; (2) deliver only in cannery crates; (3) there is to be continuous delivery; (4) pick on Sunday, so cannery workers can have Sunday off."

Instructions from the cannery for picking strawberries were terse: "(1) Do not pick berries when wet; (2) a minimum of 18 pounds per crate; (3) one nail on the cover of the double-decker crate to make easier inspection; (4) soft berries go in cannery crates as cull berries bring most if packed in barrels."

The July 17, 1923, *Gresham Outlook* notes, "The new herd law passed last year is to be strictly enforced by the new constable and justice of the peace. Most stock owners have been disregarding the law, but they have been given personal notices that all loose stock will be taken up."

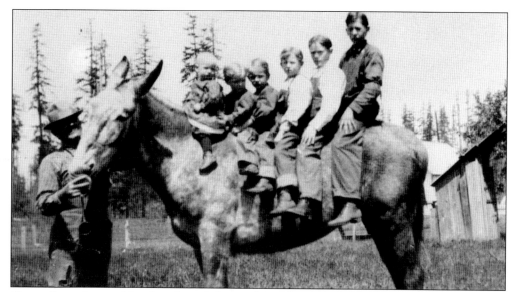

Generally, mules need less hay than do horses. Most do not require grain, and they do not tend to overeat it. The mule has a reputation for being more sure-footed than his equine cousin and is less likely to panic, even when carrying the six Milan boys—from left to right, Robert, Daniel, James, Leo, William, and Jack. (Courtesy of Colleen E. Watkins.)

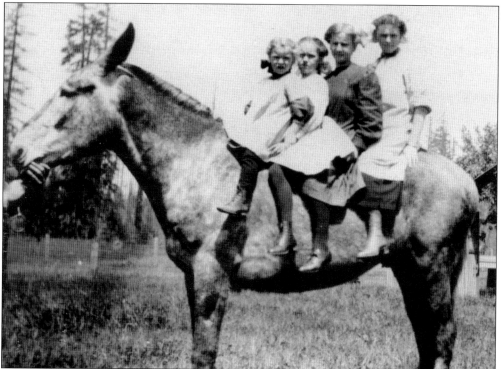

Thomas and Mamie Milan owned mules and used them for hauling wood, rocks to the crusher, and a host of other applications, including entertainment. They had 11 children who survived. Shown here are the Milan girls enjoying a ride on Shorty—from left to right, Ann, Nora, Margaret, and Helen. (Courtesy of Colleen E. Watkins.)

The mild weather and rich soil of east Clackamas County made it perfect for growing berries of all kinds. The Scenic Fruit Company in Boring employed hundreds of people from all over the county for picking, packing, and transporting the fruit, especially strawberries and raspberries. Many students earned the funds they needed for school clothes and books picking berries during the summers.

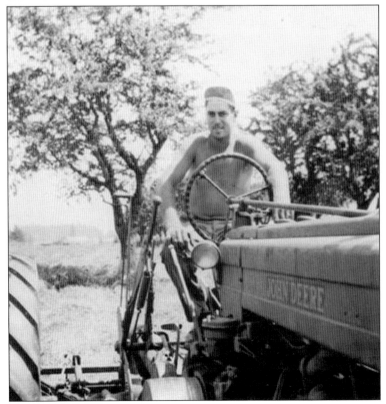

Arnold Moore Jr. is pictured in 1945 using a modern invention, the John Deere tractor, to work the fields that provided pasture for the cattle on the Moore Dairy. The dairy still operates as part of Organic Valley, a farmer-owned cooperative with 1,652 farm families nationwide and the only organic cooperative in the Pacific Northwest. (Courtesy of Linda Parker.)

In 1950, Gary and Linda Moore were already learning the dairy business with the help of their mother, Jean (Mrs. Arnold Moore Jr.). Of the six Boring dairies in the first half of the 20th century, the Moores' is the only one still working today. Gary remembers his grandfather bemoaning the coming of tractors because they compacted the soil so much. Pictured are, from left to right, Gary, Jean, and Linda. (Courtesy of Linda Parker.)

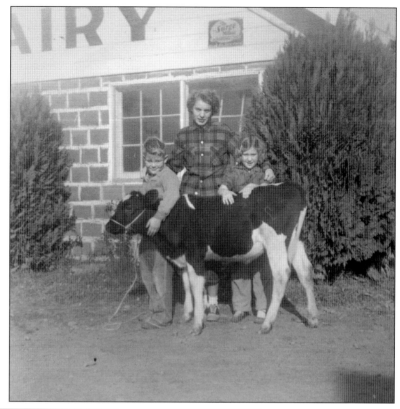

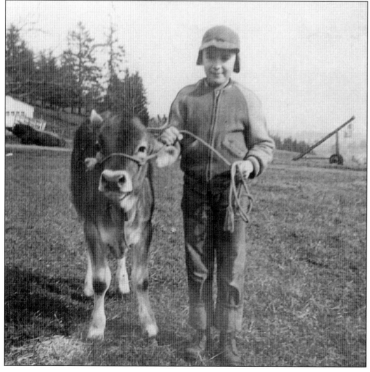

In 1949, Gale Meier had to do chores to earn the money to buy his first 4-H calf to raise on the Meier dairy farm west of Boring. "By the time I was ready to marry, I owned 18 head of cattle," he said. "My parents bought 16 of them, and that's how we were able to make the down payment on our house." (Courtesy of Gale Meier.)

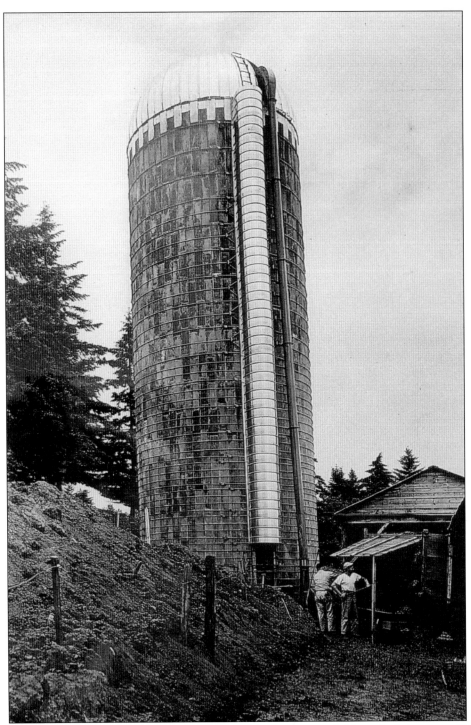

The Meier Dairy silo was used for storing fermented, high-moisture fodder to be fed to cows. Here, brothers-in-law William Morrison (left) and Earl Meier are feeding cattle. John Meier (Gale's grandfather) founded the dairy, and his sons Lawrence and Earl took it over when they came of age. (Courtesy of Gale Meier.)

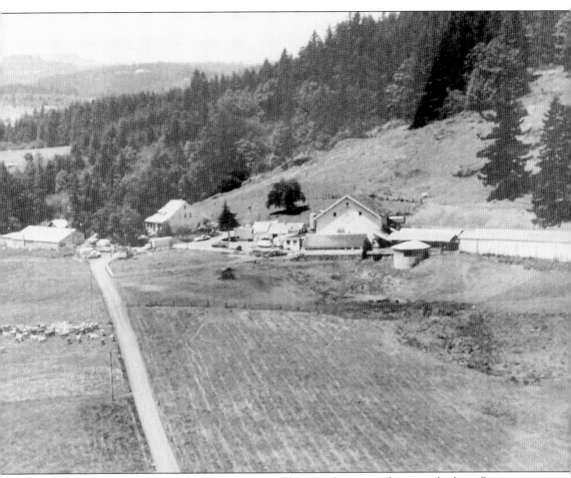

In the early 1960s, Meier Dairy built a new milking parlor on its farm overlooking Boring to the east. At 15, Gale Meier started driving his own dairy route for the family business, with his grandmother riding shotgun because he did not have a license. His father and uncle sold the milk routes in 1972. (Courtesy of Gale Meier.)

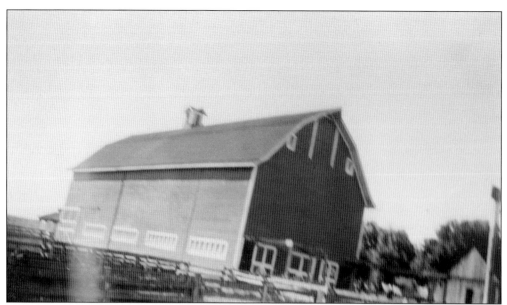

In 1948, Wallace Aschoff owned one of the many successful dairies in the Boring area. During the Columbus Day storm in 1962, Wallace Aschoff's barn on Amisegger Road collapsed. The hayloft fell on the cows below, killing 20 registered Guernseys. With the barn gone, Aschoff needed a place to keep the remainder of his cattle. (Courtesy of Janet Karlen Edmondson.)

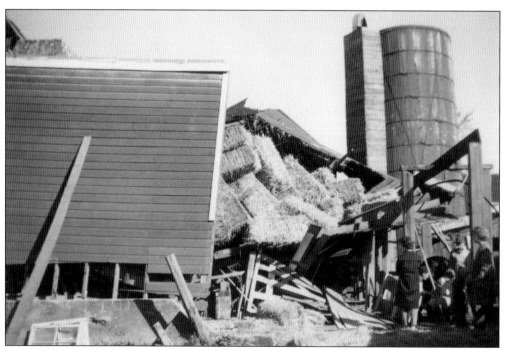

Nearby dairy farmer John Gantenbein let Aschoff keep the rest of his herd in his barn while a new one was being built. When construction was finished and the cattle were returned, Aschoff asked how much he owed for boarding them. "Nothing," replied Gantenbein. "We had a barn. You needed a barn." (Courtesy of Janet Karlen Edmondson.)

The Gantenbeins' Big White Barn is still a landmark on Kelso Road south of Boring, the central point of a thriving collection of dairies belonging to the Gantenbeins, the Vetsches, the Aschoffs, the Karlens, the Meiers, and the Moores. Although they were technically in competition with each other, they were always ready to help one another when needed. (Courtesy of Janet Karlen Edmondson.)

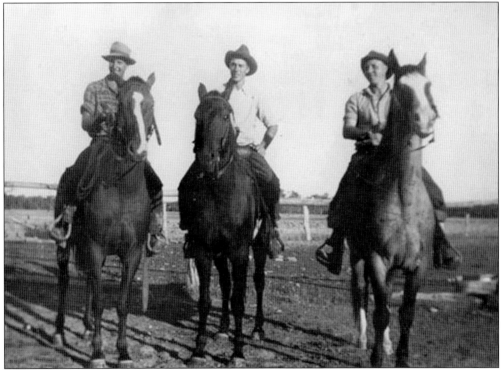

Dairy cows do not require long trail rides, like the Old Chisholm Trail, but neighbors sometimes got together on horseback to move a herd from one pasture to another. Shown here, from left to right, are John Gantenbein, Arnold Moore Jr., and Emil Karlen in 1942. (Courtesy of Linda Parker.)

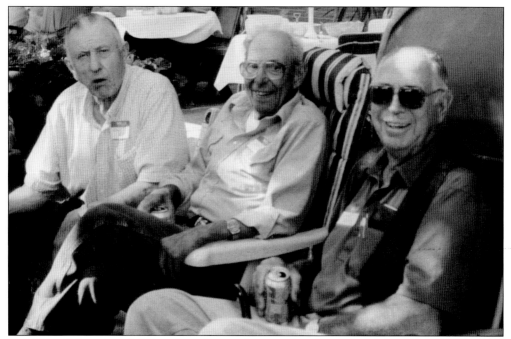

In 2003, old friends and fellow dairy farmers have gathered to reminisce about the glory days. Emil Karlen (left), John Gantenbein (center), and Arnold Moore Jr. recalled the struggles they had—burning out stumps to clear the land, dealing with cantankerous cows that resisted being milked, or birthing calves that needed pulling. (Courtesy of Janet Karlen Edmondson.)

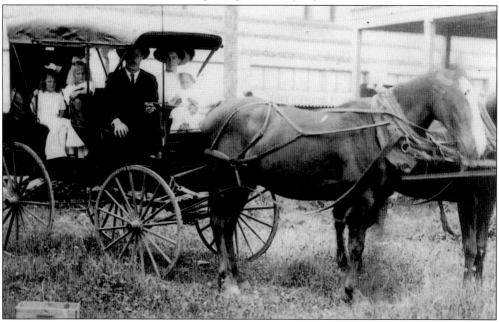

In 1916, John Gantenbein's parents are taking the family on a Sunday outing. From left to right in the carriage are Margaret, Lilly, Christian, Anna, and Henry. Christian Gantenbein, John's father, died three months before John was born. Anna worked in the shipyards as a welder's helper during World War II to finally pay for the farm. (Courtesy of Janet Karlen Edmondson.)

Four

SAWMILLS AND LUMBER

Before Valberg Lumber Company or Vanport Manufacturing, there were seven sawmills operating in the Boring area, making it, for a time, the second-largest lumber-shipping town on the West Coast. One of the first mills was owned and operated by the Hillyard brothers in the 1890s on Johnson Creek about a mile north of Boring.

In 1901, Oregon Water Power and Railway built an electric light railway as far as Boring. Previously, logs had been dragged to the mill by horses or oxen and shipped by horse wagon to Troutdale's rail line. The railway made Boring the lumber-shipping center for the Boring-Sandy area.

In 1902, O.A. Palmer established one of the first mills in Boring. Not much is known about Palmer, but it is noted that he donated land for the first church in Boring: the one that is now the Bell Tower Wedding Chapel on the corner of Richey Road and Church Road.

Adolf Hertrich came to the United States from his home in Germany in 1953 to attend the University of Michigan and study forestry. He was drafted and spent two years in the US military, later returning to the University of Michigan and earning his forestry degree in three years. He worked for the US Forest Service during the summers and took a job with Mount Hood Forest after graduation. In 1967, he left the forest service and started Vanport Manufacturing with Joseph Yoerger, John Hillyard, and James Moore.

The mill had been closed for two years and was not equipped with the new technology needed to process the smaller logs. Vanport remodeled the Valberg mill and installed this necessary equipment.

The company would eventually purchase the Harris Stud Mill, the Chaney Mill, and the Bruss Mill site, which is now part of the sewage-treatment plant and part of the land that Hertrich donated to the Boring Station Trailhead Park and Grange in 2007. Today, the company has offices in Canada, China, Russia, and Japan. Vanport's office headquarters is still in Boring, and it leases its mill site out to other businesses, such as McGriff and Decorative Bark.

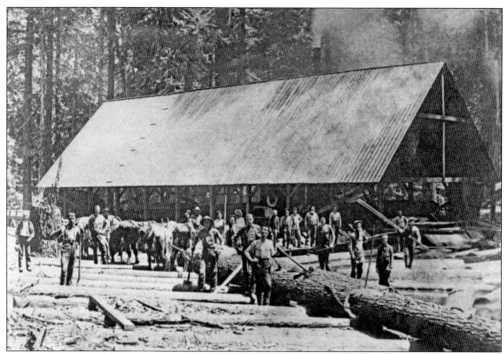

James and William Hillyard's sawmill, one of the very first in the area, operated in the 1890s about a mile north of Boring. The mill cut 30,000 board feet of lumber per day, mostly railroad ties, though not for local use, since the railroad had not yet been built.

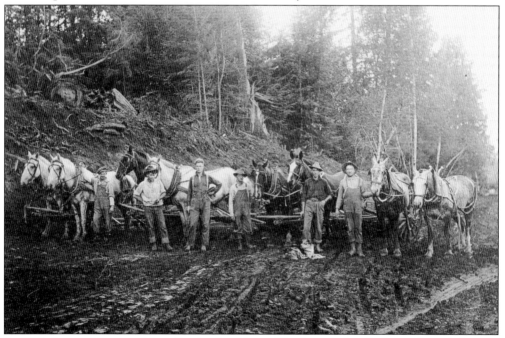

By 1920, the need for a road from Portland to Mount Hood resulted in fairly steady work for men and draft horses building the Mount Hood Loop Highway, now Orient Drive, a mile or so north of Boring. Lester "Pick" Irvin (far left) has his hand on the hame of the harness.

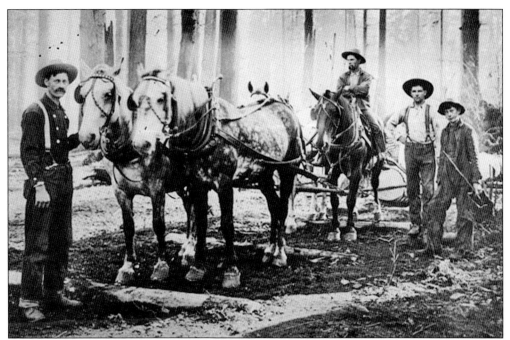

Will Bell of Kelso used both horses and mules to drag logs to the landing for shipping. To make the load easier for the draft animals, skids were built and lubricated, giving rise to the expressions "skid road" and "grease the skids." The boy on the right carries a bucket of grease for that purpose.

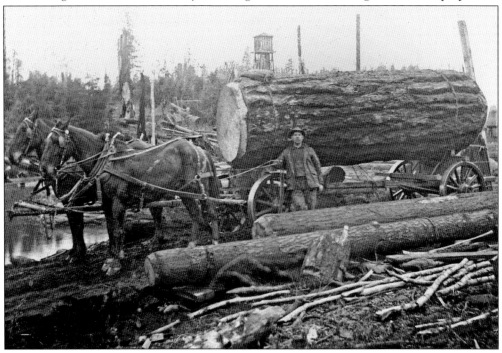

Before there were trucks and trains, logs had to be dragged, hauled on horse-drawn wagons, or transported via waterways or chutes (where hillsides were steep enough). Loading was usually done with a steam donkey, and unloading was accomplished by rolling the logs into the millpond.

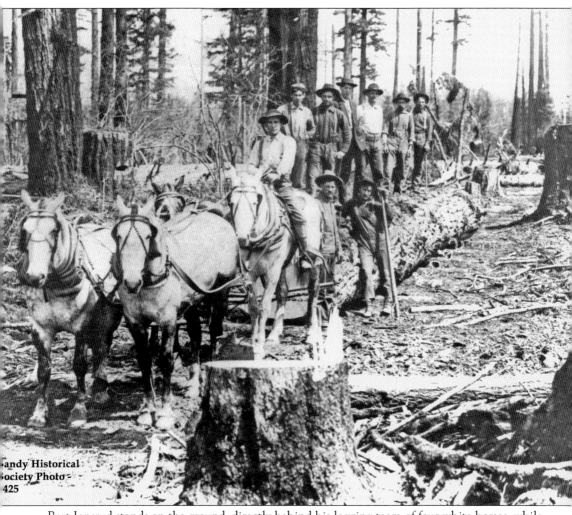

Bert Jonsrud stands on the ground, directly behind his logging team of four white horses, while yarding a sawlog to the Jonsrud brothers' mill near Kelso. Bert was a constable in the Sandy area for many years. The man riding the horse is unidentified. Standing on the log, second from the front, is Will Bell. Fourth from the front is Bert's brother, Joseph Jonsrud, the mill manager.

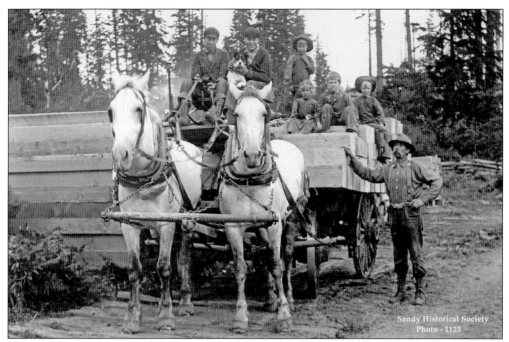

Not every load of wood was milled in Boring. Wilhelm Guldenzopf, with his five sons and daughter Lydia, is near Kelso, taking a load of ties to the railroad in Boring, either to be used on the new railroad or to be transported to another spur nearby.

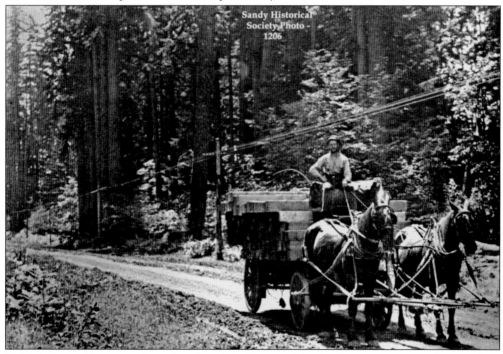

Del Jadwin, on his way to the railroad yards in Boring with a load of ties, pauses in the area then known as "Lover's Lane," a stretch of road with a thick stand of tall fir trees on each side. This road is now a four-lane federal highway carrying hundreds of cars per hour.

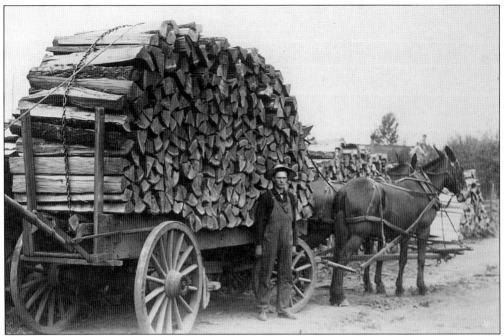

Not all timber was used for lumber or railroad ties. Much of it was used for heating or for steam power in the mills before electricity was available. In this image, Bill Milan stands with a load of cordwood near Kelso, preparing to go to market or to individual homes. (Courtesy of Kathleen Milan and Sandy Historical Society.)

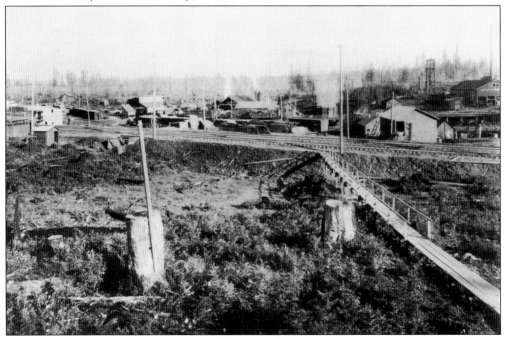

Even after the train came to Boring in 1904, both the locomotives and Palmer's sawmill were steam powered. This view from the porch of the Hotel Boring shows the boardwalk to the railroad tracks. Left of center and just barely visible is the first train depot.

A bird's-eye view of Boring in 1967 displays almost the same point of view. Where there was a boardwalk, there is now State Highway 212. In the center foreground is the Assembly of God church, which had been the Hotel Boring, then the Odd Fellows Hall, and is now the site of the Polaris Snowmobile dealership. (Courtesy of Kathryn Bigelow.)

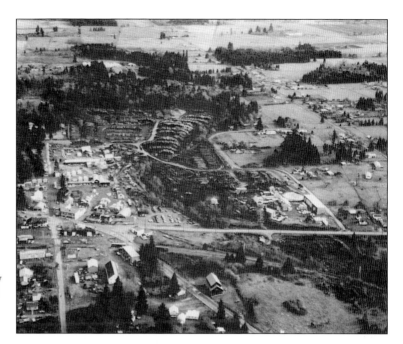

On April 28, 1922, local newspapers reported that "John Valberg has opened a lumber yard at Haley Station. August Lekberg has the honor of being the first customer." By May 12, Valberg had leased a piece of land from W.R. Telford, planning to move his lumberyard to Boring from Haley Station.

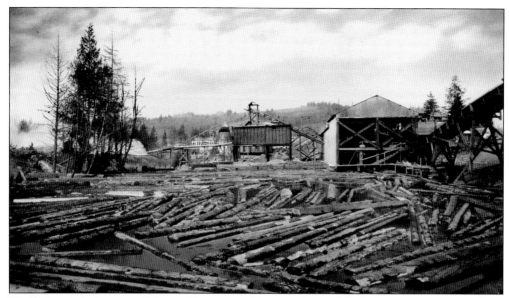

Until tractors were powerful enough to move logs, ponds simplified their transportation from storage to the sawmill hoist. Storing logs in water has the additional advantages of minimizing fire risks, washing away dirt that could dull saws, and preventing splitting of logs, which might otherwise dry before milling.

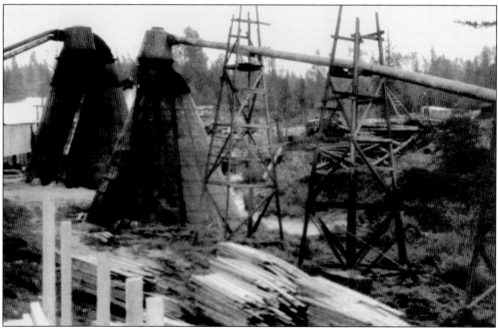

Wigwam burners were a cheap and effective way to get rid of the sawdust, bark, and other wood waste around sawmills. A military officer assigned to protect Oregon from Japanese attacks complained that they lit up the state like "bulbs on a Christmas tree." Environmental concerns and new ways to use the waste caused the practice to be discontinued. (Courtesy of James Valberg.)

Robert Rolli was one of the lumber-handling–equipment operators, who were responsible for moving logs and finished wood products in the yards and mills. Equipment used for this activity includes conventional forklifts and carriers like this one, which straddled and carried a stack of lumber. (Courtesy of Jean Rolli.)

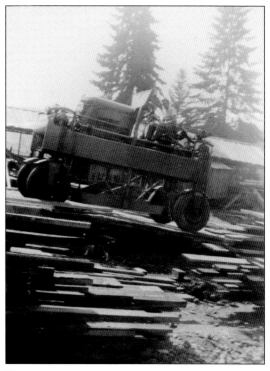

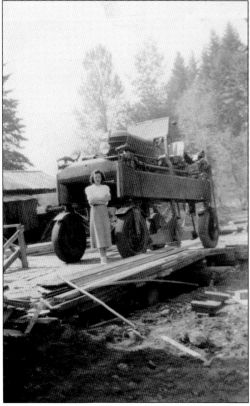

One of the advantages of living and working in a small town was being able to share lunch with one's spouse. Jean Rolli, who worked in the Boring Post Office not far from the Valberg Lumber Company, often joined her husband for the midday meal. Not everyone was so fortunate. (Courtesy of Jean Rolli.)

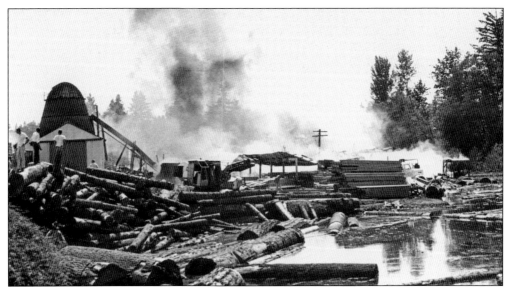

A constant concern of sawmills was the threat of fire. John Valberg's son Kenneth, who inherited the Valberg Lumber Company, saw his mill go up in flames in the 1940s. When the Summit Mill burned—shown here in a photograph taken by John's grandson James—Kenneth rushed to his own mill and spent the day hosing it down. (Courtesy of James Valberg.)

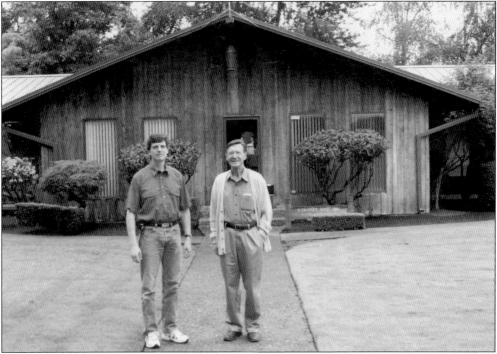

Adolf Hertrich founded Vanport Manufacturing in 1967. His son Martin is now the vice president of Vanport International. In 1999, Vanport had 300 employees and was dependent on logs from the Mount Hood National Forest. The Forest Service stopped selling timber there, and the mill closed that year. Vanport Manufacturing became Vanport International. (Courtesy of Vanport International.)

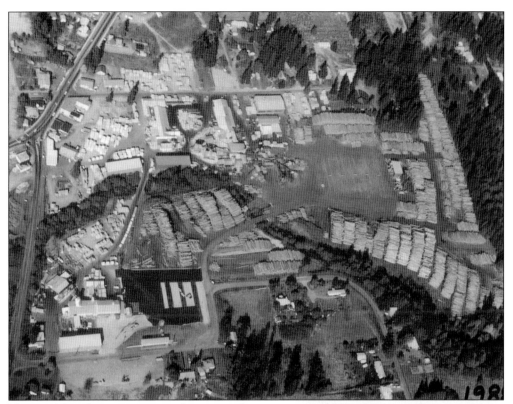

Vanport Manufacturing increased its size and organization substantially in the years after it bought the Valberg Mill, based on the availability of logs from the Mount Hood National Forest and technology for processing small logs. In a single pass, the mill could convert a small log with a diameter of 3.5 to 12 inches into a rectangular piece suitable for mainstream milling. (Courtesy of Vanport International.)

What little boy raised in the forest does not want to grow up a lumberman like his father? Milton Meinig is slightly less than four years old when he poses on a log near a sawmill at the foot of Mount Hood. His family has lent its name to streets, parks, businesses, and geographical features throughout the area.

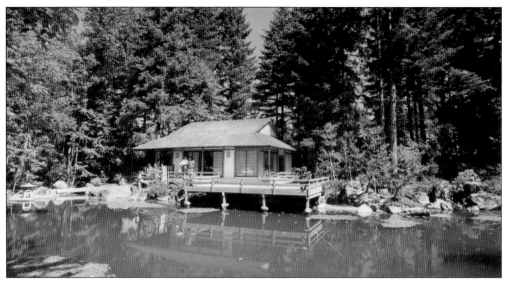

Vanport's Japanese teahouse was begun in 1980 to demonstrate Vanport's commitment to Japanese tradition and quality. Each piece of lumber was carefully hand selected as it came through the sawmill. The teahouse serves as a familiar environment to showcase the variety of products Vanport offers, in use in their final forms. (Courtesy of Vanport International.)

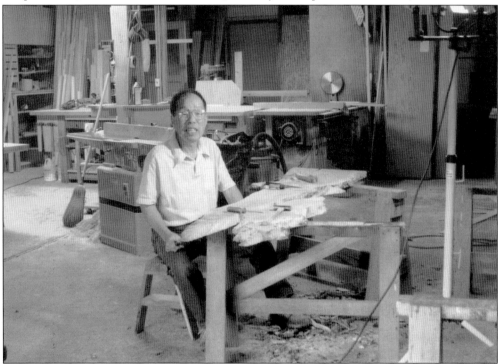

The classically trained carpenter Noboyuki Matsushita built the Japanese guesthouse using traditional post-and-beam construction techniques. This involves intricate hand carving of the wood at each of the joinery locations, much like pieces of a puzzle. The end result is a balance of craftsmanship and natural beauty. Matsushita has a wood shop on the Vanport property, where he makes custom wood furnishings. (Courtesy of Vanport International.)

Five

HERE COMES THE TRAIN

The symbiotic relationship between trains, sawmills, and farms was remarkable. Without trains, sawmills and farmers could not get their product to their customers; without mills, the trains would have no ties for their roadbeds; without farms, the mills and railroads could not feed their employees.

The January 31, 1899, *Gresham Outlook* reports, "Considerable excitement has been caused in this and neighboring precincts on account of a railroad rumor. It is claimed that the O.R. and N. contemplates building a branch line from Fairview provided the people will give it the right of way plus ten percent of the capital."

That plan did not materialize, but in 1901, George W. Brown, chief engineer of the Oregon Water Power Railroad, explored the upper Clackamas River country to find a location for a dam. His reconnaissance proved successful, and Morris Brothers Investment Bankers in Portland hired L.R. Meyers to build the railroad from Gresham to the dam site, named Cazadero, Spanish for "hunting ground."

The railroad was completed on September 28, 1903, and took 900 passengers to the dam site. Before 1907, the trains were pulled by steam engines; after the powerhouse was operational, they were pulled by electric engines. The train carried timber, farm produce, mail, and other goods up and down the 36 miles between Portland and Estacada—through what was then called Boring Junction. To encourage weekend use, the rail corporation developed destination parks along the line, and weekend outings were common to all points along the corridor

The entire line was electrified by the new Cazadero power plant and by an auxiliary power plant in Boring, so that electric trolleys could run the entire line, which served both freight and passenger service. Half of the line was abandoned by the early 1930s after the wooden trestles at Deep Creek burned. In 1958, passenger service was dropped, and only freight was carried. In 1990, the remaining tracks were removed. By 1996, the right-of-way had been turned into a bike trail as far as Gresham. The last two miles to Boring were paved and dedicated in February 2014.

The first trains had to be steam powered since there were no power stations and no electric lines. Deep Creek Canyon had a spur line leading off the main railroad line from Portland to Estacada.

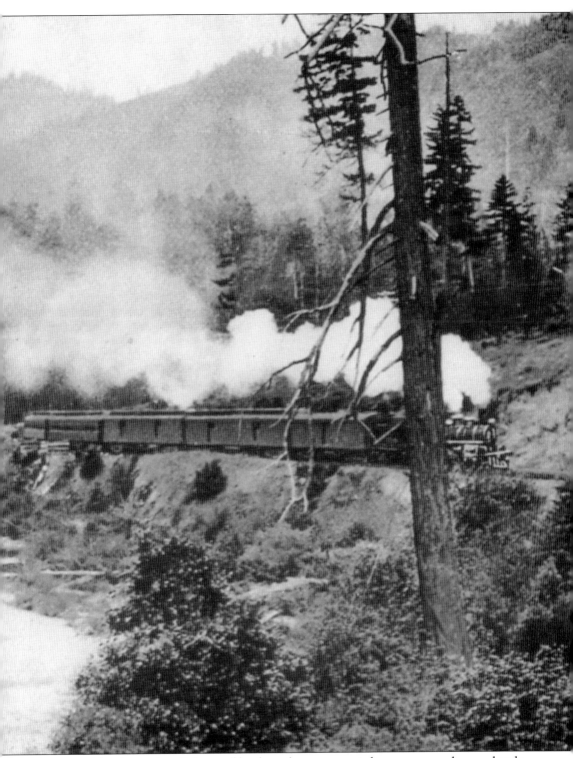

Most carried freight—primarily logs and lumber—but some carried passengers, and on weekends, even excursionists. (Courtesy of Gordon Watkins.)

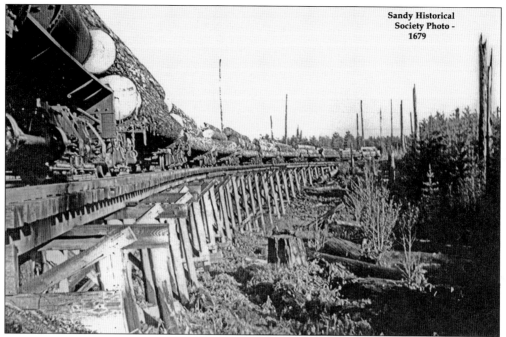

Loggers in the 21st century look with envy at the sight of these high-quality logs being transported on railroad cars by the Dwyer Logging Company from Wildcat Mountain on a spur line off the Portland to Cazadero tracks that ran up Deep Creek Canyon in the 1920s.

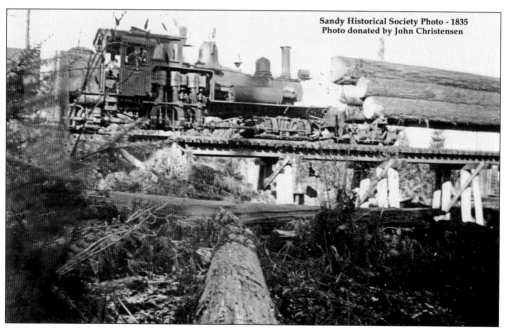

With no railroad switches, turnouts, or turnarounds, these spurs were confined to one-way traffic. When an engine had pulled its load to the end of the track, it had to reverse engines and run backwards. On this spur running up Deep Creek Canyon toward Dover District, the engine is doing just that. (Courtesy of John Christensen and Sandy Historical Society.)

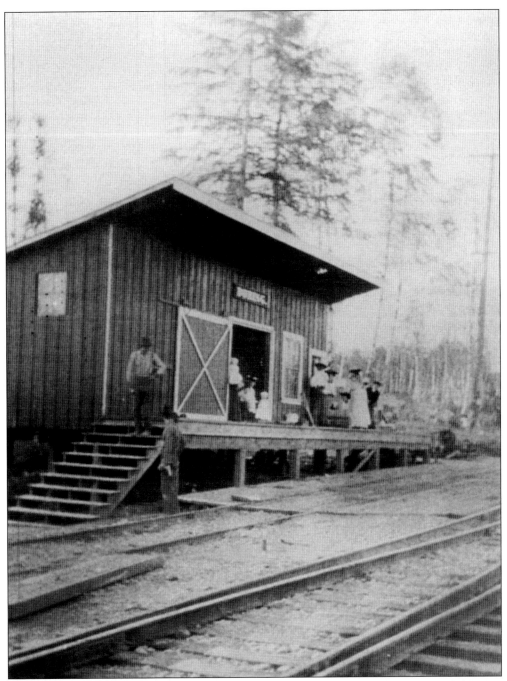

The first Boring depot was about as primitive as it could get. Still, people paid to get on the train and ride to Gresham, Portland, or even Estacada. Farther down the tracks, mills and loggers loaded forest products, and farmers were able to send their produce, especially dairy products, to market.

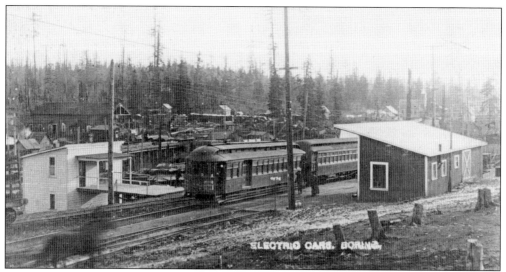

The white building across the track from the depot was Ritzer's Confectionery. Looking southeast, from the north end of the first depot, one sees the Methodist church, which still stands on Richey Road. Just across the creek on the left is the wood-burning power plant built in 1903. Two of the earliest trolley cars are headed toward Portland.

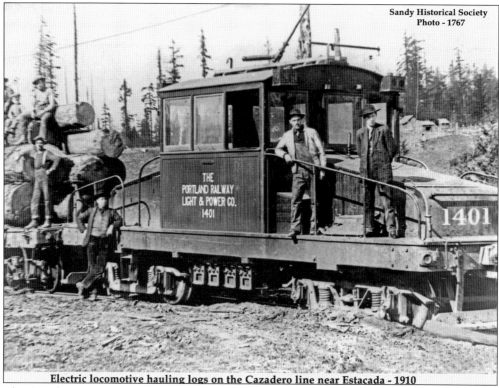

Electric locomotive hauling logs on the Cazadero line near Estacada - 1910

The Cazadero Line ran through Boring to Estacada and beyond, ending at the Cazadero Dam, which supplied the electrical power that ran the train. In 1981, a conservation effort was made to convert the railroad line to a hiking/biking trail, and that conversion is now completely paved from Portland to Boring.

A six-hour trip from Boring to Portland by horse and buggy took one hour by the electric trolley. Most people called them "streetcars" because of their similarity to Portland's streetcars. In the white shirt beside this 1920s railway mail car is Vernon Maulding, whose granddaughter Jean Rolli worked in the Boring Post Office for many years before her retirement in 1992.

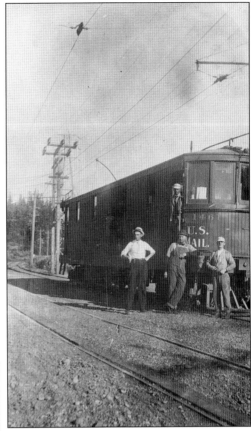

Haley Station, a mile north of Boring, no longer exists—except as the name of a road that intersects with Telford Road where the station used to be. The stations on the interurban were approximately one mile apart. All were sheltered and had benches, and a few had freight houses.

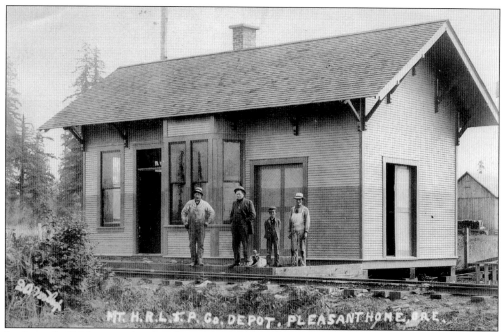

In the early 1900s, several railroad lines served small communities now served by the Boring Post Office. One of these was Pleasant Home, a few miles northeast of Boring. This depot is now part of the Pleasant Home Saloon, where the author has sometimes played harmonica with a bluegrass band called Hell or High Water. (Courtesy of Dean Gray.)

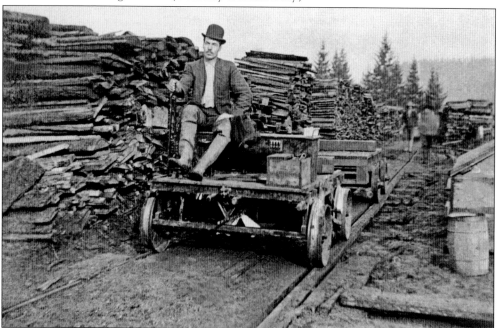

The first train over the Mount Hood Railway to Bull Run in about 1910 was this "speeder" (railway motorcar, track-maintenance car, crew car, or inspection car), also known as a "draisine." Although it is slow compared to a train or car, it is called a speeder because it is faster than a human-powered vehicle.

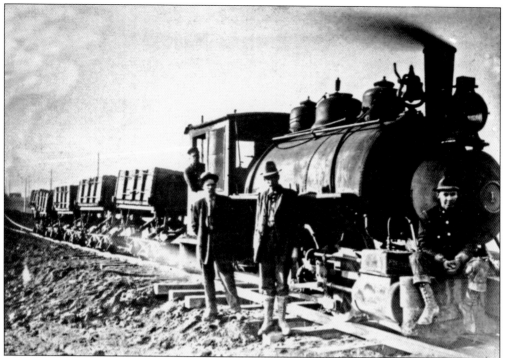

In 1912, there was a steady stream of trains with supplies and equipment for the Bull Run power plant east of Portland. This locomotive is heading away from Kelso station, where it might have taken on a load of ties and other lumber from the mills in Boring. Bull Run supplied hydroelectric power for the Portland area for nearly a century and is still Portland's main water source.

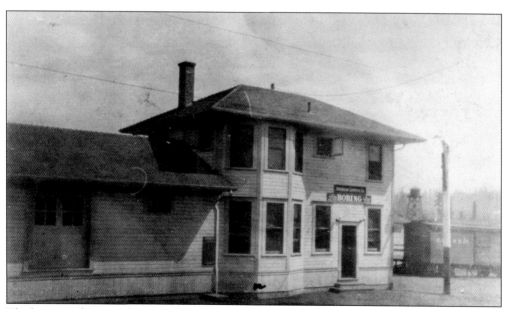

The latest rendition of the oft-replaced Boring Station train depot featured the American Express Company. There were at least three versions of the depot, which periodically had to be rebuilt, either because of fire or inadequate space, service, or provisions for the passengers' comfort.

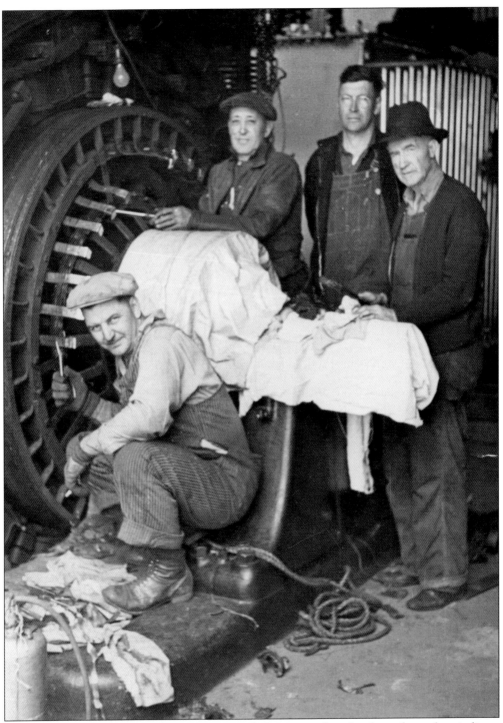

Portland General Electric workmen maintained the power plant for the railway electric lines, overseen by Jean Rolli's grandfather Vernon Maulding. This plant did not generate electrical power, but converted the alternating current transmitted by the power lines to direct current, more manageable by the trolleys.

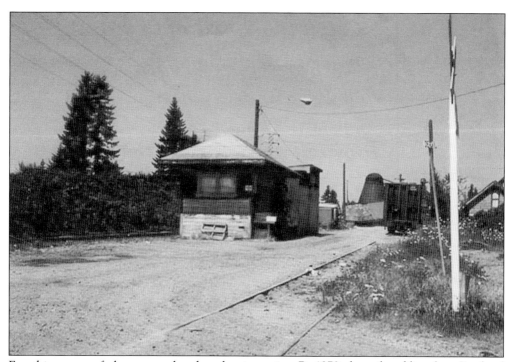

Few things are as forlorn as an abandoned train station. By 1970, the railroad line from Portland to Boring no longer carried passengers or produce, but it was still used to transport lumber. In the background of this image is one of the wigwam structures used to burn waste timber material. For ecological and economic reasons, they are no longer used or even allowed.

This car, a victim of the elements and the ravages of time, seems to mock its former purpose while still holding an undeniable attraction. There is something romantic about trains; they have come to represent discovery and adventure. Abandoned trains, on the other hand, have a different kind of charm.

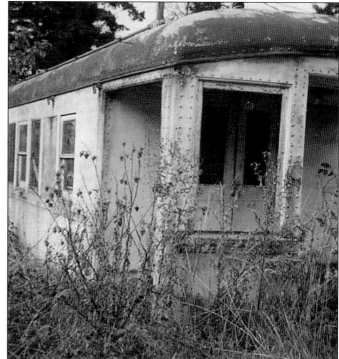

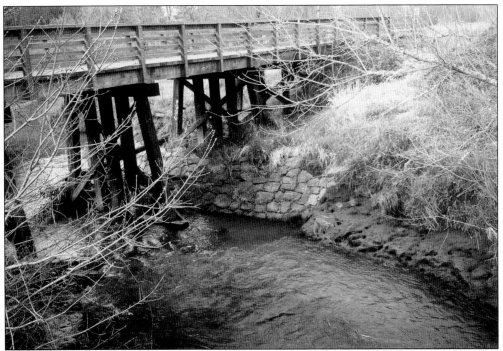

A trestle bridge across Johnson Creek on the Springwater Trail evokes memories of a time when the train carried passengers, produce, and mail up and down this roadbed many times a day. As folks hike, bike, or ride horses on this trail today, some often wish so many bridges had not been replaced by ones made of concrete or steel. (Courtesy of the author.)

On this stretch of the Springwater Trail, which follows exactly the course of the old Cazadero railbed, one can travel for miles and never lose sight of Mount Hood, the highest peak in Oregon at 11,249 feet. Although considered dormant, it is known to have erupted about 200 years ago and is thought to be the Oregon volcano most likely to erupt. (Courtesy of the author.)

Six

Becoming a Community

Boring has never been incorporated as a city, town, village, or hamlet, but from the earliest written references, it has clearly been thought of as a coherent community. There was already a school on Amisegger Road when William Boring donated the land for the first Boring School. Named the Fern Hill School, its beginning and end dates have not been recorded, but it is known that there was a friendly rivalry between the two, for Miles Aubin reported that in August 1897, "the students of this place have adopted as their yell: 'Zip zip, go bang. What's the matter with the Fern Hill Gang?'"

The tiny, one-room schoolhouse built on land donated by William and Sarah Boring became the hub of respectable social life in Boring. Church services, formal debates on issues of national importance, and other community events were held in the schoolhouse before a larger school could be built in 1904. In 1907, the first church building was constructed on land just south of Boring, donated by O.A. Palmer.

In 1893, locals organized the Damascus-Boring chapter of the National Grange of the Order of Patrons of Husbandry, a fraternal organization that encouraged families to band together for the promotion of the economic and political well-being of the community and agriculture. The Grange Hall in Boring is still a center of community activities, such as the Community Planning Organization and the Nutz-n-Boltz community theater.

In 1903, with the expectation that the railroad would bring great quantities of commerce, the town of Boring Junction was platted—showing blocks, streets, and alleys—in hopes that it would become a major hub for transportation and business. A post office was established that same year. Before long, there was a meeting place for the Independent Order of Odd Fellows in the building that had housed the Hotel Boring and later became the Assembly of God church. Eventually, a volunteer fire department was organized after several extensive fires destroyed parts of the town and nearby mills. Boring was on the map whether or not it would ever be incorporated.

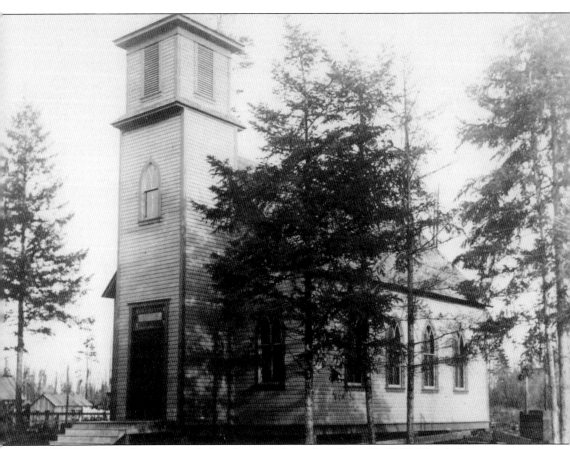

The new Methodist Episcopal church was dedicated on June 23, 1907. The dedicatory sermon was delivered by John H. Coleman, DD, president of Willamette University. John Flynn, DD, who had been preaching more than 50 years in Oregon, spoke in the afternoon on Oregon's pioneer days. A basket dinner was enjoyed by all participants in the afternoon and evening.

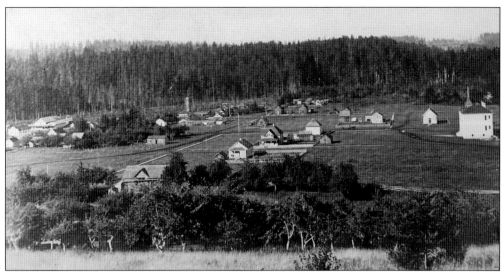

As the population increased, so did the need for more and bigger schools. Rather than send their children all the way to the Boring School, parents in the nearby community of Cottrell built a small school of their own, which they had to replace before long with the larger building shown on the right.

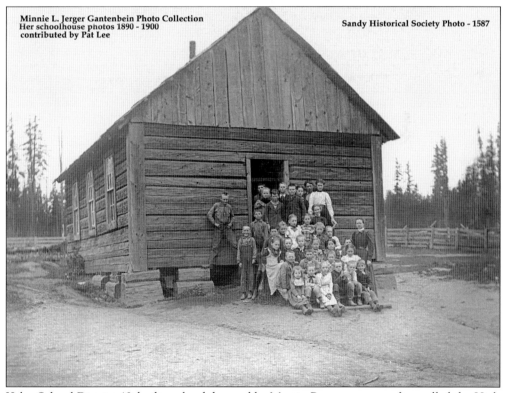

Kelso School District 19, built on land donated by Martin Peterson, was at first called the High Forest School. Among those listed as early workers in starting the school is Torkel Jonsrud, who served as clerk for many years and kept detailed records. The first teacher was Carrie Phillips.

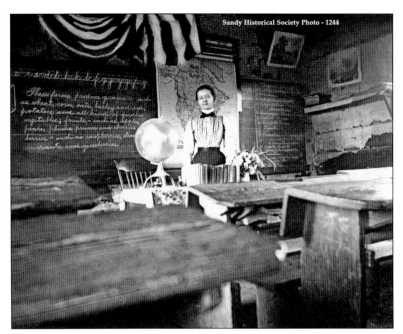

Anna Olson Rodlun was the teacher at Kelso High Forest Log School in the 1890s. She was the aunt of Philip Jonsrud, local historian and grandson of pioneers Torkel and Kari Jonsrud, who came to Oregon from Minnesota in 1877 to settle in Kelso. The school year began on July 15, with the teacher's salary at $40 a month.

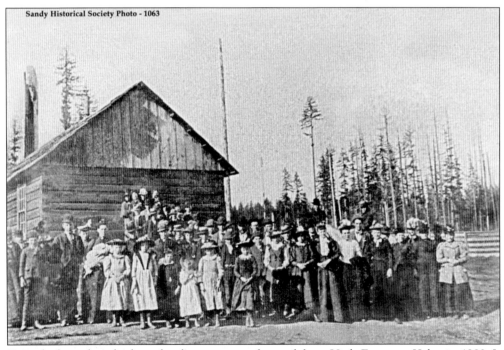

Records show that the log school's name was changed from High Forest to Kelso in 1889. It burned in 1905 when a slash fire at a nearby logging operation got out of hand. Before it did, a reunion of sorts was held by many of the students who had attended and some of the teachers who had taught there.

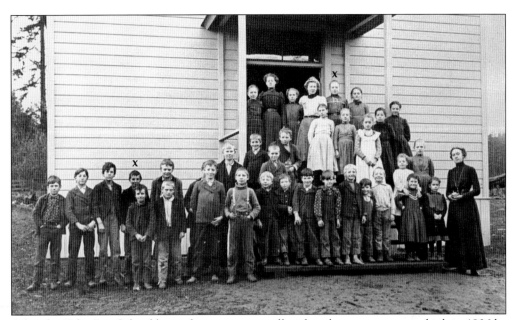

After the Kelso Log School burned, a new one—still with only one room—was built in 1906 by John Jonsrud at a cost of $584. Matilda Olson (later Mrs. Robert Jonsrud) taught the last year in the old building and the first year in the new one. Included in the duties of the teacher were various janitorial responsibilities.

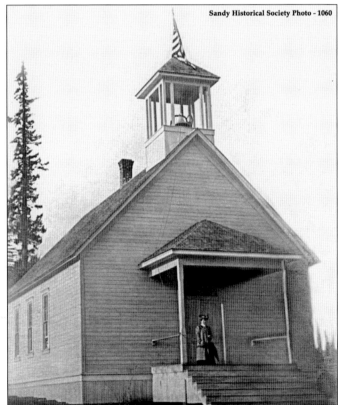

The 1907 school census lists 93 boys and girls between the ages of four and twenty at the school in Kelso. In 1908, a second room was added at the cost of $857. Kelso united with Sandy Grade School in 1945 and soon after that, the Sandy Grange purchased the vacated building and converted it into a Grange hall, which is still used for that purpose.

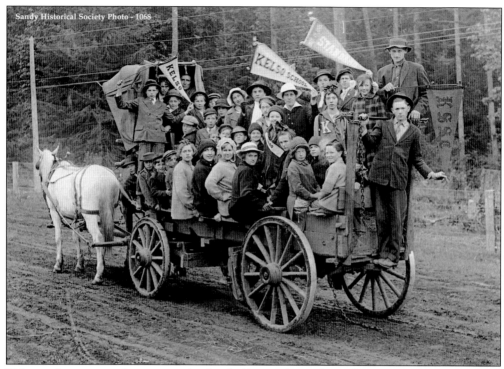

Kelso students are on their way to the Sandy Grange fair and parade in Sandy in 1914. Teacher Sophie Barnum is standing in the center wearing a white hat and dark dress. Mildred Decker is the second child from the right in the second row. Eunice Jonsrud Barnum is standing in front of the teacher.

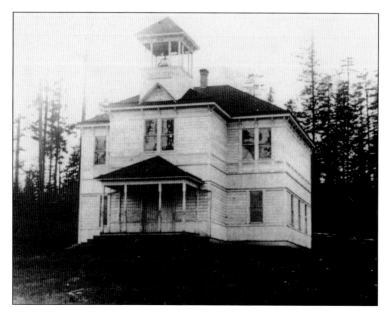

The first school in the Boring area was the Fern Hill School on Bradley-Richey Road. The first one known by the name Boring Grade School was built in 1883 on land donated by William Boring. In 1904, a four-room school was built on what would become Valberg property, a mile south of Boring. Boring School seemed rather, well, boring, so it was named Oregonia (pictured).

74

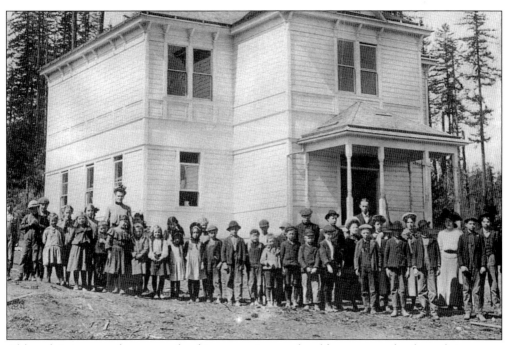

Although it was a modern, new school in comparison to the old one-room school, conditions were still primitive by today's standards. There was no indoor plumbing, much less electric computers or other visual aids. A 40-by-60-foot play shed was added in 1918.

A 1923 *Gresham Outlook* reports, "Miss Lillian LeKander, teacher at Deep Creek School, has given a Halloween party for her pupils. The Deep Creek children are enjoying their dictionary and newly slated boards. The school received material for curtains. Evelyn Heddin received first prize for the curtain most neatly sewed."

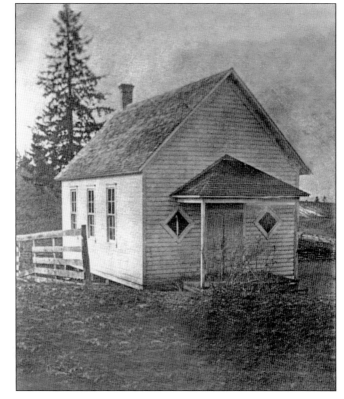

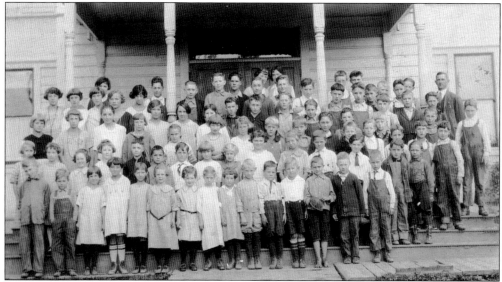

In 1924, Willard Boring, fourth from the left in the rear, attended Boring Grade School. Oregonia would not have indoor plumbing or electricity until 1930. It did have two large outhouses and a woodshed that held 25 cords of wood. Norval Naas, who would become principal of Boring Elementary, taught here for three years.

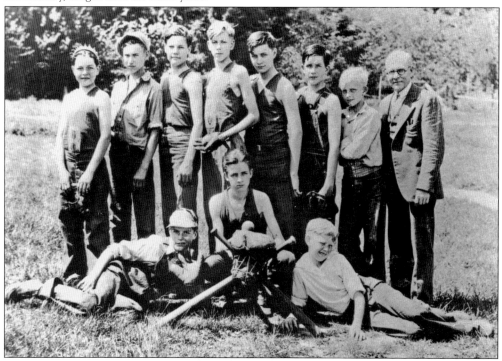

Boring was justly proud of its grade school baseball team, as well as of the adult town team. Miles Aubin, schoolteacher and unofficial chronicler of Boring education, never failed to report on their prowess. When he substituted as a teacher, the students often reported, "Mr. Aubin did not teach anything but baseball." Norval Naas is shown at the right. The present elementary school is named for him.

In 1928, Boring Grade School graduated nine eighth graders in the spring. From left to right are (first row) Henry Gantenbein, Otto Kampfer, and Samuel Mallicoat; (second row) Miles Aubin, Erwin Childs, Marion Duley, Kenneth Valberg, Grace Mallicoat, and Eunice Carlson.

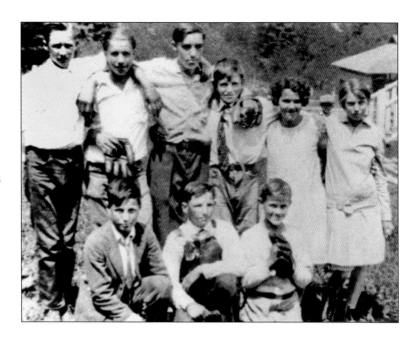

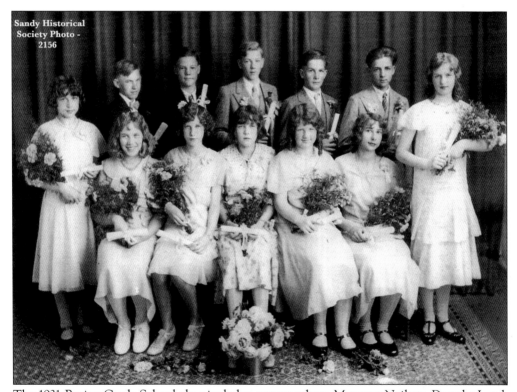

Sandy Historical Society Photo - 2156

The 1931 Boring Grade School class includes, among others, Margaret Neilsen, Dorothy Lund, Ruth Child, Lucena Richey, Earl Carlson, and Clifford Richey. By the time these students graduated, the school had indoor plumbing and electricity, which may be the explanation for their pleasant glow.

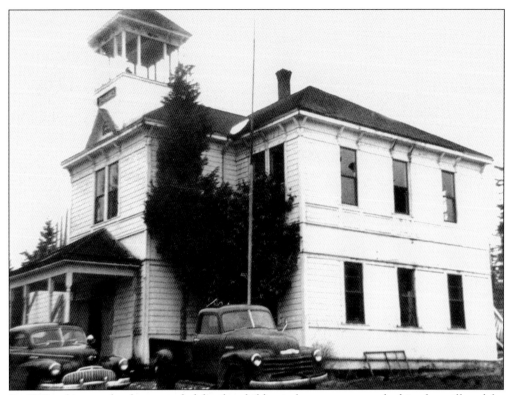

By 1948, a bigger school was needed for the children whose parents worked in the mill and for growing families. The old building was abandoned, and a new one built at the north end of Boring. Norval Naas was the new principal. Robert Boring remembers starting the third grade in one building and finishing it in the new one.

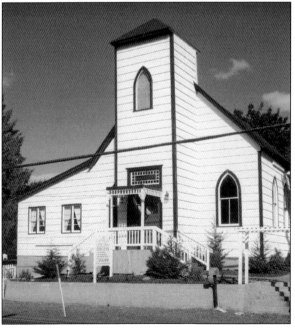

The Methodist Episcopal church building, a center of genteel social activity since its dedication in 1907, is now the Bell Tower Chapel, which can be rented for weddings, receptions, and special events. Its owners invite guests to "ring in [their] celebration with the original chiming church bell!"

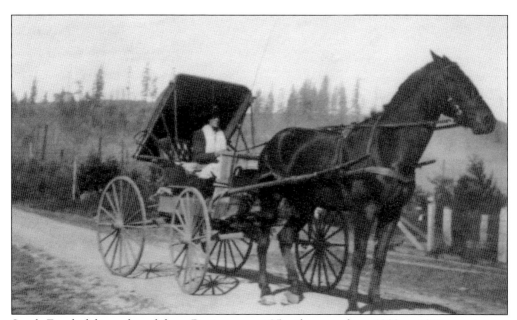

Sarah Frank delivered mail from Boring over a 25-mile route from 1909 to 1919, starting on horseback and switching from buggy to Model T only in her last year. She drove over bad roads, some of which were corduroy (roads made of logs laid side by side). In the winter, she took a thermos and a foot warmer—a drum with a drawer that held a brick of hot coal.

Sarah's husband, Reuben Frank, lost an arm in a sawmill accident. He made an attachment that he could wear on his stub arm to hold a violin bow, joined a group of one-armed musicians, and went on the vaudeville circuit as a musical novelty act. His daughter Cora says he taught all his children to love music.

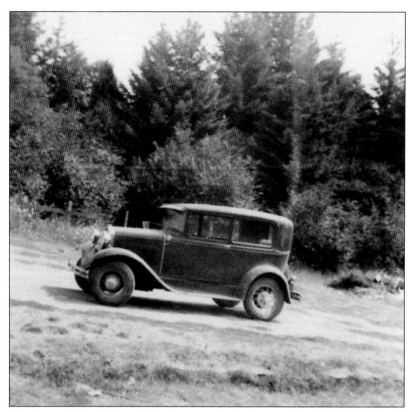

Sarah Frank's son-in-law Floyd Lake took over the mail route in 1919 and eventually made deliveries in this Ford Model A after starting the job using a horse and buggy. Floyd delivered the mail on rural routes for 38 years until his death in 1956. He and Reuben Frank built a house in Boring in 1917 at the intersection of Highway 212 and Dee Street.

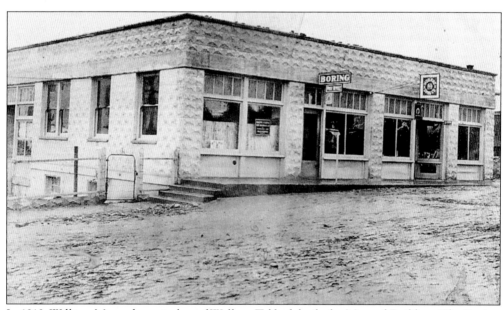

In 1913, William Morand, son-in-law of Wallace Telford, built the Morand Building. The Boring Post Office occupied the east half from 1913 to 1933. The west half was a drugstore, until those patent drugs were moved across the street to the building that now houses the Timber Tavern.

The Valberg Building housed the Boring Post Office from 1933 to 1976. Its distinctive architecture made it the downtown area's centerpiece. Other businesses rented space there, too, as they do now. On the second floor were apartments where a number of Boring notables dwelt while preparing other living arrangements. Among them was Mae Humphrey, the postmaster from 1934 to 1961.

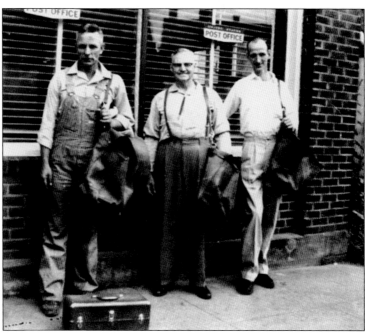

These three stalwart deliverers of the US mail—Floyd Lake (left), Otis Rich (center), and Harry Muse—pose in front of the Boring Post Office when it was in the Valberg Building. They took the postman's creed seriously: "Neither snow nor rain nor heat nor gloom of night stays these couriers from the swift completion of their appointed rounds."

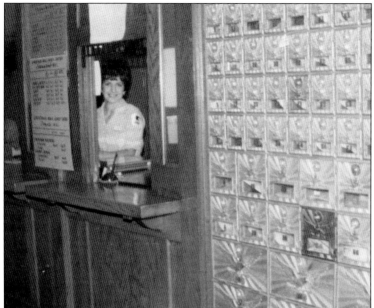

Jean Rolli was a postal clerk in the Boring Post Office for 35 years before she retired in 1992. Here, she is shown sorting mail and preparing to assist postal customers in 1960, when the post office was in the brick Valberg Building in the heart of downtown Boring. The post office was moved from the Morand Building across the street in 1933.

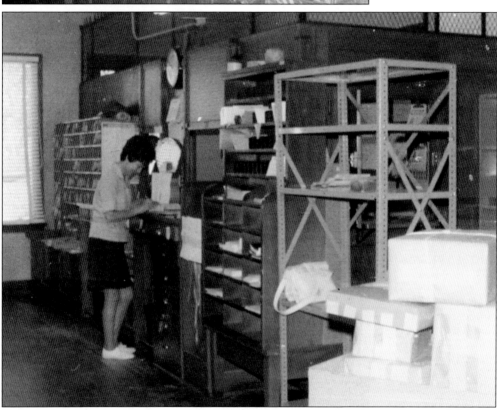

Few patrons of the post office were ever allowed to see the inner workings of the mail-delivery system behind the scenes. It is easy to overlook all the duties a postal clerk must perform quickly, accurately, and efficiently, such as receiving letters and parcels, selling postage, and filling out and selling money orders.

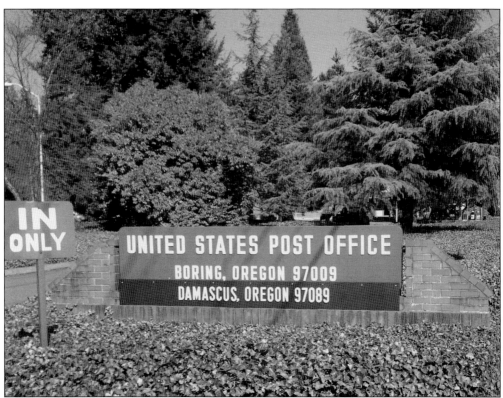

In 1976, the federal government authorized the construction of a separate structure and built it on Highway 212 headed out of Boring toward Highway 26. The Boring Post Office also serves Damascus residents, although Damascus has its own ZIP code. Damascus had enjoyed its own post office since 1867, before Boring took it over in 1904. (Courtesy of Kathryn Bigelow.)

In its sylvan setting a block away from the center of town, the new post office is a far cry from the muddy roads and mill-town atmosphere of a century ago. Conveniently located across the street from Clackamas County Bank (the only bank in Boring) and next door to the fire department, it is a center of civic activity. (Courtesy of Kathryn Bigelow.)

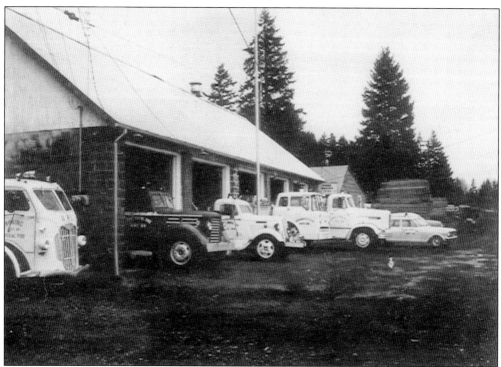

On February 13, 1947, a mass meeting held at the Boring-Damascus Grange Hall led to the formation of a volunteer fire department. Districts represented were Boring, Damascus, Deep Creek, Union, and that part of Orient lying in Clackamas County.

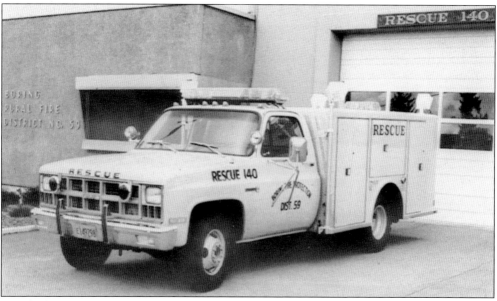

In only three years, the Boring Volunteer Fire Department listed 26 members, including many of the most prominent Boring residents, with names like Boring, Naas, Valberg, Telford, Maulding, and Rolli. It boasted 18 with first-aid cards, 10 with advanced first-aid cards, and two instructors. (Courtesy of Kathryn Bigelow.)

In 2001, the City of Gresham presented Boring with a restored 1936 Dodge fire truck. Here, Daniel O'Dell reads the proclamation announcing the presentation. The truck sees active service from time to time, but most often, it is used for Boring's annual festivities, especially the tree-lighting ceremony in December, when Santa arrives in the lit-up fire truck. (Courtesy of Kathryn Bigelow.)

By 1970, the Boring Fire Department, still mostly a volunteer force, had larger, improved quarters on Highway 212 and had vastly improved its training and response time. Thanks to a $330,000 bond issue approved in 1968, the new station and the new apparatus were made possible. (Courtesy of Kathryn Bigelow.)

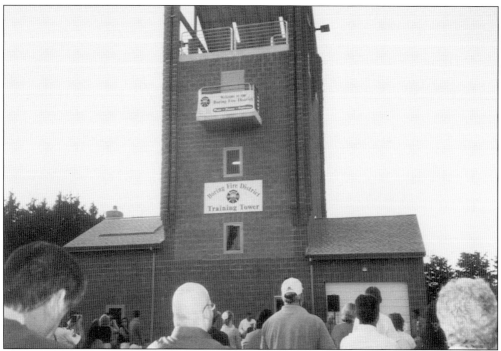

A new training tower was dedicated in 2003, providing the department with the ability to prepare firefighters for situations that might overwhelm them if encountered for the first time with no experience. The Boring volunteers have earned national awards for their expertise in handling emergencies in simulated situations, especially using the Jaws of Life. (Courtesy of Kathryn Bigelow.)

The department never takes anything for granted, including its constituents. It is always on the lookout for new volunteers, offering training and incentives for citizens to become involved with community safety and emergency management. Besides the training tower, the station provides extensive facilities for training and other community involvement. (Courtesy of William White.)

Seven

BUSINESS BOOM

The timber industry was important to the early development of Boring, as was agriculture, but without other businesses, there could have been no lasting community. The railroads were a major factor, too, but in the 1920s, the growth of markets and services—as well as various types of amusement—became prominent. Perhaps a harbinger of things to come was this local published opinion: "March 19, 1897—With McKinley as president, people of this community are expecting better weather and better times."

Access to national communication and transportation increased both a sense of community and the desire for more goods than could be produced on local farms. Before television or the World Wide Web, radio was the new technology of the day. The June 6, 1922, *Gresham Outlook* reports, "W.R. Telford has moved his radio into the store for the benefit of the customers. The concerts have been coming clearly from as far north as Seattle and as far south as Los Altos, California. It was reported that Monday morning Mr. Telford got Chile."

On November 24, 1922, citizens learned that Boring's new butcher shop had opened with I.D. Turner on the end of the cleaver. It was just in time for the Thanksgiving rush. The P.R.L. and P. Company had installed a new streetlight at the south end of the depot, a welcome addition to Boring's poorly lighted streets.

"The year 1922 has been a progressive year for Boring. Most notable of the new buildings is the Boring Amusement Clubhouse operated by Mr. Bert Waller. Dances, parties, ball games, and civic events are held in this nice hall built by Mr. Waller," reads an article in the local newspaper from the time. "Among the new businesses in Boring are I.D. Turner's butcher shop and the John Valberg Lumber Yard. Other signs of progress in Boring are the new gravel bunkers in back of Metzger's garage, the extension of the streetlights by the P.R.L. and P. Company, and Mr. W.R. Telford's new radio which entertains his customers. Some notable accomplishments were H.C. Compton's experiments in agriculture and his winning of several prizes at fairs."

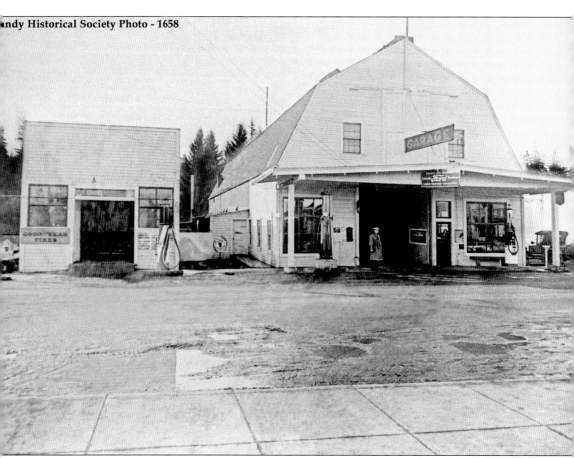

At the turn of the century, every town needed a blacksmith shop, and blacksmithing was an invaluable skill. Moving with the times, Robert Smith, who had met with some success blacksmithing and selling Studebaker buggies, relocated his business to larger quarters and began servicing and selling automobiles, gasoline, and tires. Evidently, he also shifted from Studebaker to Ford.

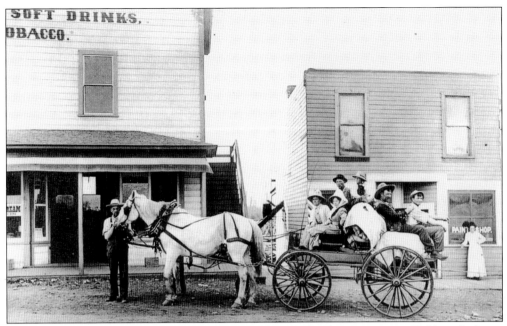

In 1915, the automobile had not quite become the chief mode of transportation. Holding the horse in front of the confectionery is Joseph Lunday. Hattie Giles Turner is in the driver's seat, Nellie Lunday is in the middle of the hack, and Ivan Turner is seated in the rear. The confectionery burned in 1922 and has been replaced by the Timber Tavern.

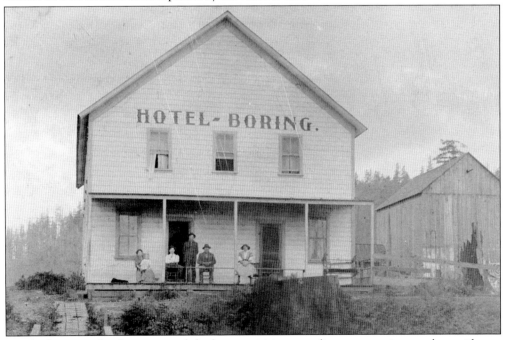

People always need a place to stay while they are visiting, traveling, or preparing another residence. The Hotel Boring met that need until most of the town rented, built, or bought more-permanent housing. Over the years, it has been used as a store, an Odd Fellows hall, a Baptist church, and an Assembly of God church. In its place now is Mount Hood Polaris Snowmobile Sales Company.

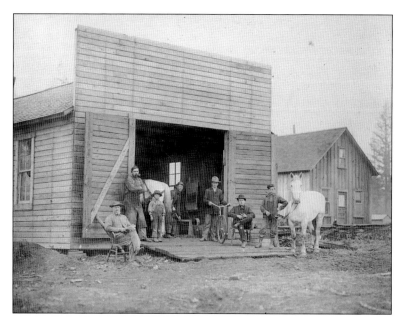

At one time, Boring boasted two livery stable/blacksmith shops, one at each end of town. This may be the building that is still standing and now houses the antique shop at the corner of Highway 212 and Dee Street. It has also seen other uses as a gasoline station and a video store. Repurposing has become a way of life for Boring.

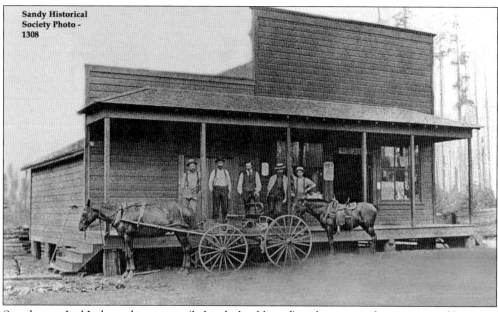

Sandy Historical Society Photo - 1308

Storekeeper Joel Jarl stands at center (behind a buckboard) with a group of customers and hangers-on at his Kelso store in the early 1900s. Jarl also served as postmaster during the time Kelso had its own post office (1892–1904). As transportation became faster and more economical, fewer small post offices were needed.

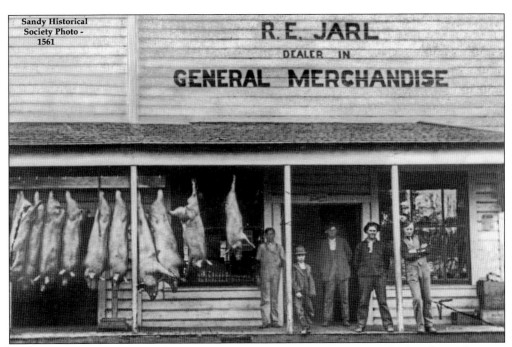

R. E. JARL

DEALER IN

GENERAL MERCHANDISE

Robert Jarl also had a general merchandise store at Kelso. It is uncertain whether this is the same store remodeled or whether Robert was Joel's son. Without big department stores, supermarkets, or even dependable mail order, a general store in a rural or small-town setting was necessary to provide a broad selection of merchandise.

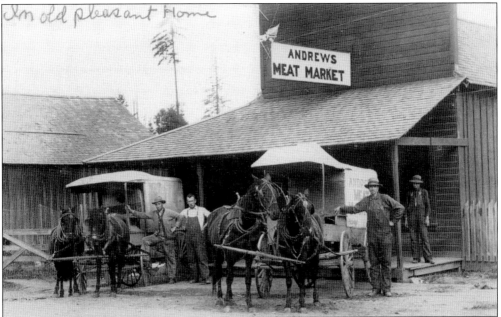

ANDREWS MEAT MARKET

Pleasant Home was one of the smaller communities served by the Boring Post Office. Andrews Meat Market made home deliveries. Without refrigeration, people relied on ice or extremely prompt deliveries to keep the meat fresh. From left to right in this image are Henry Hemmers, Albert Gray, Robert Andrews, and Melvin Andrews. (Courtesy of Dean Gray and Sandy Historical Society.)

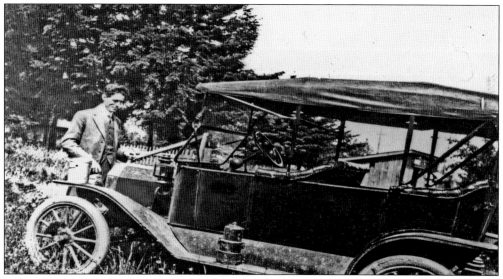

Robert Jonsrud checks the radiator water level in his Ford touring car in 1911. Despite the old bromide about "not making them the way they used to," automobiles are a great deal more reliable than they were back then. Though the cars were beautiful if they have been kept up, they required much more maintenance and oversight.

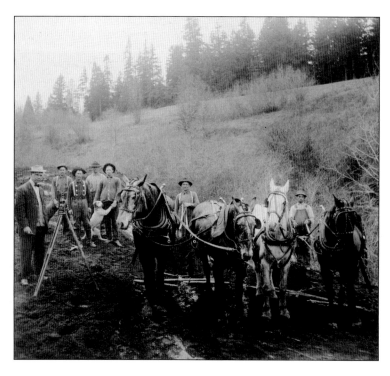

As businesses and homes spread out, more interconnecting roads were needed. At first, volunteer workers supplied the labor for these, but there was eventually a need for professional involvement. John Revenue, grandson of one of the area's pioneers, built this road, which still bears his name, before heavy equipment and diesel-powered tractors were the industry standard.

Winters sometimes—not often—got pretty harsh. Not too many braved the snow to shop at Telford's store. Then, as now, severe weather was not good for business, unless it was the business of fuel or emergency equipment. The best strategy for homeowners was to hunker down and wait till the storm passed.

At least in those days, during a storm like this, one did not have to worry about the electrical power going out. There was no electrical power except that used to run the trains, and that had not yet been extended to residences, businesses, schools, streetlights, or emergency equipment.

W.R. Telford bought what is now McCall's Store from W.J. and Eliza Roots (his wife's parents) in 1910 and operated it as W.R. Telford General Merchandise until 1940. He was a railroad agent, county clerk, county commissioner, and, finally, judge. Wally Road and Telford Road (now 272nd Avenue) carry his name.

The Vetsch family came to America in 1878, bought land in Boring, and started a dairy. When they established a butter, cheese, and pasteurization operation in Portland, however, it was no longer just farming, but a business. Shown here are eight of the fifteen horse-drawn delivery wagons they used daily to supply their customers with fresh dairy products.

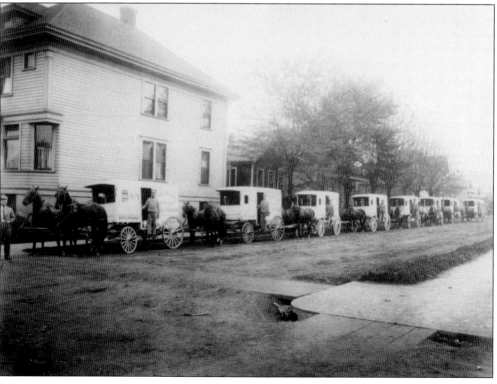

John Valberg built this structure in 1932. It contained apartments on the second floor, automobile-repair shops in the rear, and places for various facilities on the ground floor. It has housed the Boring Post Office, a hairdresser's shop, a barbershop, a veterinarian's office, an antique shop, a sign maker's shop, and a realty office—not all at the same time, of course.

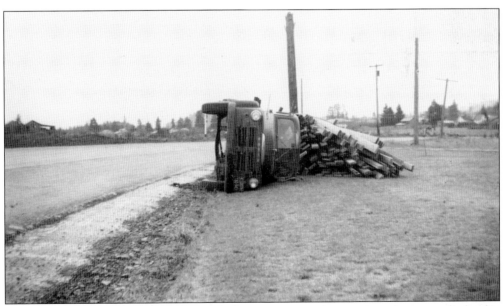

Most drivers in Boring are unfamiliar with driving on ice and snow, since they see so little of it. They usually avoid it when they can, but this driver took a chance and lost his load going around a corner on his way out of town. Jean Rolli took this picture in front of her house in 1950, after inviting the truck driver in to warm up and settle down. (Courtesy of Jean Rolli.)

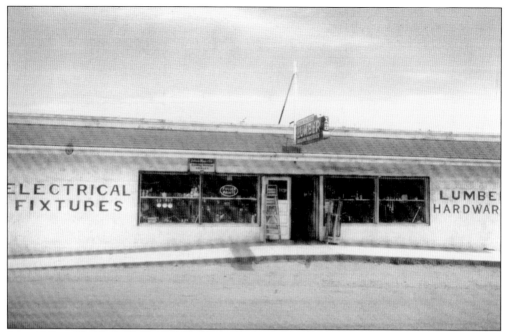

John Valberg had a hardware business that fronted on Richey Road just before it joined what is now Highway 212. In the early 1930s, without warning, a Clackamas County work crew altered the roadbed and raised the level so that it effectively buried Valberg's business. He built this second story on top of it and operated it for at least 40 more years.

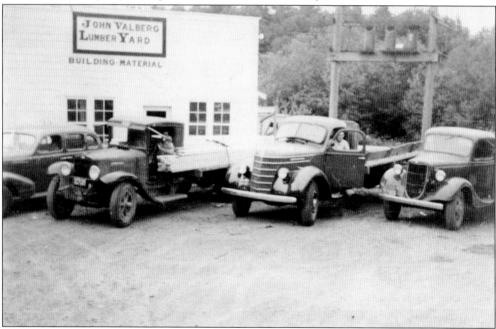

John Valberg had begun business in Boring in 1922 with lumber products given him in partial payment for what his bankrupt former employer had owed him. Determined to diversify his business in order to avoid such a misadventure, he owned a mill, a lumber business, a hardware store, and a delivery service, as well as rental property. (Courtesy of James Valberg.)

Sept. 3-25

Mr. Waller

3 Gallons Oil	@ 1.35	4.05	
50# Lead	@ 15½	7.75	
Credit to Check			6.50
		11.80	6.50
Oct 1 Balance		5.30	
Nov 9 Cr. to Cash			5.30
30 48 Lin P.S.		1.13	
200 " ¼ Round		2.00	
48 " P.73		.48	
48 " B.S.	1½	.72	
48 " O.G. Stop		.48	
20 Pcs. 2x4-16 S1S		3.93	
200 ft 1x6-S1S Com.		3.80	
6 Pcs. 1x12-16 S4S "		1.83	
		19.67	5.30
Dec 1 Balance		14.37	
12 2-2x8-18 B.S.			
1-2x6-18 A.G.	45°	.81	
		15.18	
1926			
Jan 1 Balance		15.18	
1 qt oil			.30
Mar. 27 Cr. to Cash			10.00
May 1 " " "			5.00
8 Lin 1" Mld		.80	

This excerpt from John Valberg's 1925 account book, when he was just hitting his stride in the competition in Boring for the lumber and hardware business, demonstrates his attention to detail and widespread interests. Most of the leading businesses in Boring are represented in this one-year account book. Many existing structures are made with Valberg lumber.

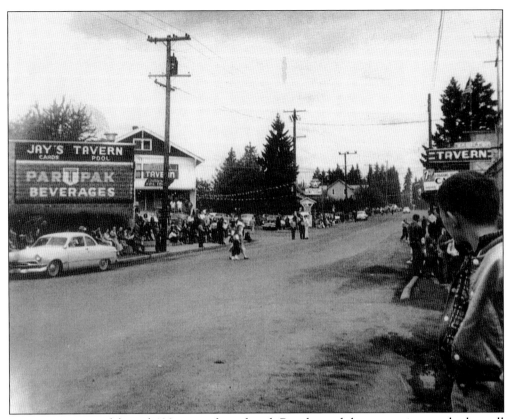

In 1959, Oregon celebrated 100 years of statehood. Parades and demonstrations took place all over the state. Damascus billed itself as "the biggest little city in Oregon," even though it was not incorporated. Neither was Boring, but it still had a parade. People lined up on both sides of the street to watch what may have been Boring's first and only parade.

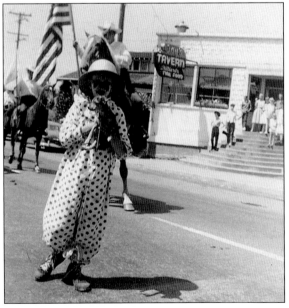

What is a parade without a clown, American flags, and horses? Judy Gregson has donned her clown suit to lead the parade, while Wilbur Shutes's Arabian horses follow close behind. Behind Gregson is Jay's Tavern, located in the building constructed in 1913 by William Morand, second postmaster of the Boring Post Office.

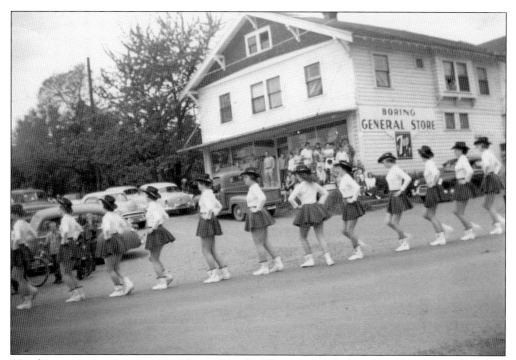

Marching majorettes are essential to a parade. These young ladies strut their cowgirl stuff in front of the Boring General Store, previously known as Roots', Telford's, and Shutes', and now called McCall's. At that time, the store fronted on Wally Road, but now the entrance is turned 90 degrees to face Highway 212.

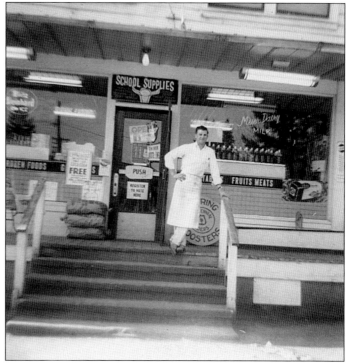

Larry Childs takes time from working behind the counter at the Boring General Store to watch the parade. In spite of the celebration, many had to work, but it was sometimes possible to sneak away for a while and see what was going on. From the deserted look of the store's entrance, it would seem the parade had mostly passed him by.

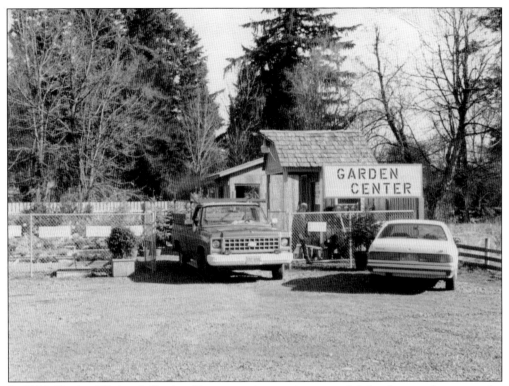

In 1986, Gordon Watkins's Garden Center was just getting started. It has become known as the Boring Square Garden Center since it now takes up nearly a whole block in downtown Boring. Watkins does a thriving business in ornamental plants, garden plants, and yard supplies. (Courtesy of Gordon Watkins.)

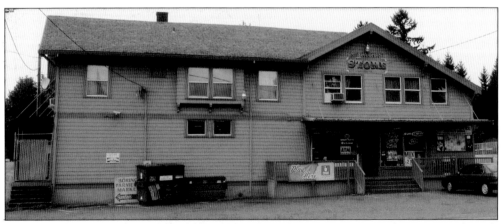

McCall's General Store is still the centerpiece of Boring's business community, having gone through many owners and many manifestations in its existence over 110 years. Although its function now is more that of a convenience store than the virtual supermarket it was in its heyday, it is nevertheless a vital part of the community. (Courtesy of William White.)

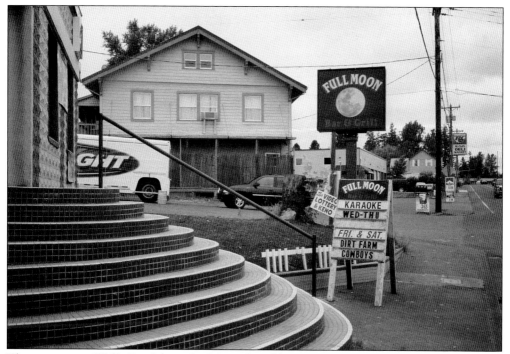

The view across Wally Road from the Morand Building to the Telford General Store had been transformed by 2008 to the view from the Full Moon Bar & Grill to McCall's Store. The Full Moon was briefly operated as a nude dancing establishment, but it did not last long. As the Not So Boring Bar & Grill, it now focuses on family dining and entertainment. (Courtesy of William White.)

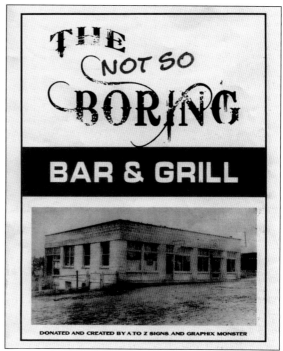

The opening of the Not So Boring Bar & Grill coincided with the dedication of the new Boring Station Trailhead Park, which lies directly behind it. Owners Michael Cooper and Victoria Thompson live and have a family in Boring. The menu features the Boring Burger, the Not as Boring Burger, and the Not So Boring Burger. (Courtesy of William White.)

Of course, not all businesses were able to continue to thrive and prosper. Paola's mink farm south of Boring was abandoned in 1976, and the family started Paola's Pizza Barn in nearby Sandy, Oregon. The falling popularity of the fur industry contributed to the demise of opportunities in raising animals for their pelts. (Courtesy of Nancy Hoffman and Sandy Historical Society.)

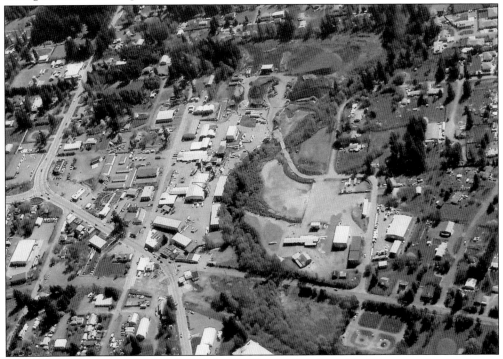

This aerial view, showing the widespread use of flat roofs and steel buildings, marks the change in Boring from a single-industry mill town to a diversified, growing community of functional, progressive businesses. What might have been another sad case of a boomtown gone bust now appears as a bustling community once more.

Eight

ON BECOMING A VILLAGE

The nationally recognized Hamlets and Villages program, unique to Clackamas County in Oregon, was begun in 1999 by the Clackamas County Board of Commissioners as a response to citizens in unincorporated rural areas—like Boring—feeling they did not have enough contact with county government. In 2005, a consulting firm began to develop the concept.

Harvard University named Clackamas County's Hamlets and Villages Program as one of the Top 50 government innovations of 2007. Harvard's Ash Institute for Democratic Governance and Innovation at the John F. Kennedy School of Government evaluated the programs based on their novelty, effectiveness, and ability to be replicated by other governments.

An all-out drive by the Boring Community Planning Organization to transform Boring into a legal entity led to a plan for the conversion of the overgrown abandoned railroad yards into a park in the center of downtown Boring proper. The park was envisioned as the centerpiece of the proposed village. An outpouring of volunteer effort started the process, and it looked as though the movement to make Boring a village would be a huge success

But with additional opportunity comes additional responsibility for citizens. Being a hamlet or village means having a need for active citizen participation, leadership, commitment, and accountability. Unfortunately, to many in the community this suggested increased taxes. After a great deal of rancorous discussion, a referendum saw the proposition defeated by only five votes.

Nevertheless, the Friends of Boring Station Trailhead Park (FBSTP), in conjunction with the Boring-Damascus Grange and the Boring Community Planning Organization, cleared the site of debris and resurfaced it with sand and gravel. They also contributed to bringing a stage, electrical access, water and sewer service, storage area, and a monument to the site and organized the first Boring Farmers Market in 2006. They have hosted community holiday events and the yearly Celebration in Boring on the site.

Funding from Oregon Parks and Recreation Department grants and a variety of local sources made possible the completion of the park and the design and construction of the final two miles of Springwater Trail between Rugg Road and Boring. The park was completed and officially dedicated May 22, 2012.

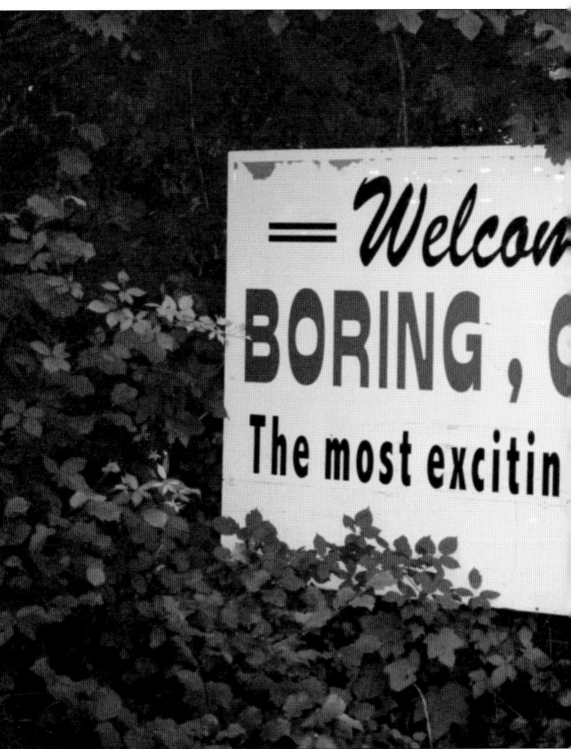

The first step in changing the image and character of Boring was to let people know where they were. For the first time, there was a sign telling travelers what place they were about to enter and

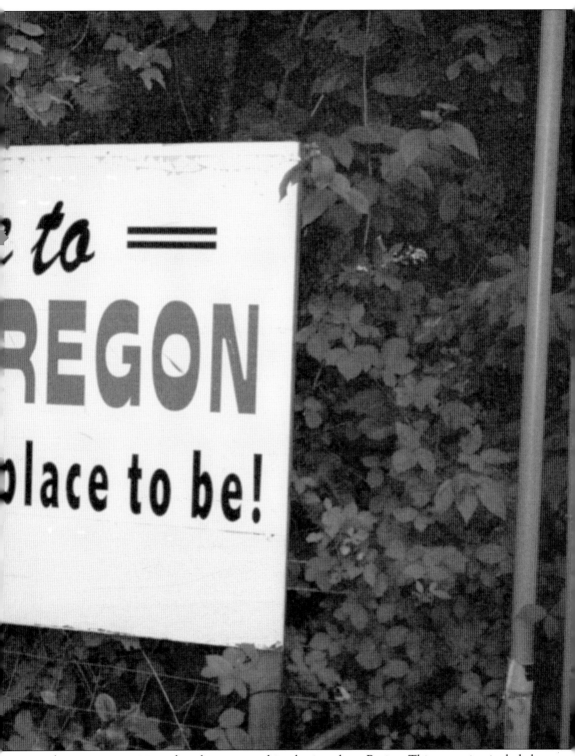

seeking to assure visitors that there was nothing boring about Boring. This campaign included not only signs but also T-shirts and other paraphernalia. (Courtesy of Kathryn Bigelow.)

Working with the Boring Community Planning Organization and other interested citizens, Portland consulting firm Cogan Owens Cogan developed a concept plan using as the centerpiece a village park in the site of the overgrown railroad yards that used to lie between the train depot and the power station. (Courtesy of Kathryn Bigelow.)

In 2005, a call went out for volunteers to help prepare the site for park construction. Local businesses offered equipment and operators to do the heavy preliminary work, contributing thousands of dollars in machinery and time to clear the brush, briars, and debris from the area. (Courtesy of Kathryn Bigelow.)

Naturally, the equipment did not always perform as needed. Here, Daniel O'Dell (left) and Lawrence Alexander, two of the leading proponents of the village concept, work at either getting a backhoe operable or adjusting it to the particular service required of it. Their expertise was invaluable in completing the project. (Courtesy of Kathryn Bigelow.)

A long-range aspect of the concept plan was to clean up and upgrade the final portion of the Springwater Trail, which follows the route of the old electric trolley that ran from Portland to Boring. Even automobile bodies had been abandoned along the trail and were completely overgrown by blackberry bushes. (Courtesy of the author.)

The Columbia Brick Works, founded in 1906, was one of 68 brickyards in the Portland area at that time and produced 150 different kinds of bricks. Hundreds of thousands of these were unsuitable or unwanted and were discarded in a vacant lot. Over the decades, a forest grew up around and through them along the railroad and trail. (Courtesy of the author.)

Preliminary heaps of debris were piled up for removal and hauling to waste disposal locations. The haulers donated their time and equipment, too. It was generally conceded that, even if the effort to become a village failed, the increase in community involvement and volunteer spirit was a net asset to the people of Boring. (Courtesy of Kathryn Bigelow.)

With the initial groundwork finished, the hard work of getting in with hand tools could begin. Here, the bare, flat earth can be seen, and the heavy equipment is ready to be hauled away, making room for good old-fashioned elbow grease with shovels, pitchforks, and pruning shears. (Courtesy of Kathryn Bigelow.)

These towers, which in years gone by had supplied power for the electric trains that ran from the hydroelectric plant above Estacada to downtown Portland, are still used to transfer power to the city. But it has been long since the towers were maintained as they should have been. (Courtesy of Kathryn Bigelow.)

Whole families got into the act, making it an excellent opportunity to instill the spirit of giving and community service while providing valuable educational opportunities in leadership and civic responsibility. Children took pride in knowing they were a vital part of creating a playground. (Courtesy of Kathryn Bigelow.)

With the brush cleared and the debris piled up, the Boring Station Trailhead actually began to look as though it might become a real park. In the background, the rear of McCall's Store can be seen, and it is easy to envision train tracks, a bustling depot, and the old Telford's General Merchandise establishment. (Courtesy of Kathryn Bigelow.)

Every year since the beginning of the movement to build a park in Boring, on the second weekend in September, the community has gathered at the site for the Celebration in Boring, featuring live music, barbecue, ice cream, games, raffles, prizes, pony rides, fire engine demonstrations, and presentations by local service groups. (Courtesy of Kathryn Bigelow.)

To further boost interest in the park—and in downtown Boring—a farmer's market was instituted to be presented every weekend during the late spring and summer. Local produce was featured, as were handcrafted art and useful implements. Usually, there was local, live music. (Courtesy of Kathryn Bigelow.)

As the park grew over the years, so did the popularity of the annual Celebration in Boring. Every year, the big-band music of the Merry Pranksters is relished along with performances by various bluegrass acts. A perennial favorite is goat poop bingo, a game in which a goat is turned loose

on a fenced-in area and contestants buy chances on where the goat will leave a deposit first. (Courtesy of Kathryn Bigelow.)

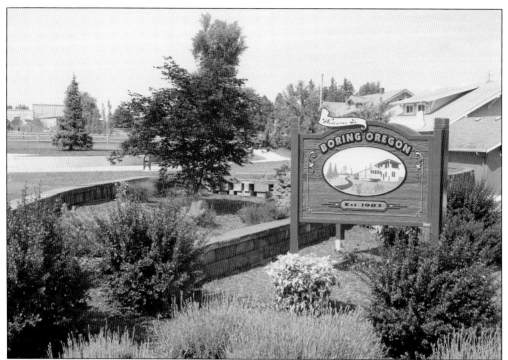

Now, when driving toward Mount Hood from Interstate Highway 205, one's first view of Boring is not of advertisements for taverns; smoke-belching sawmills; huge piles of logs and rough-cut lumber; or a weed-grown, vacant lot that used to be a railroad yard. Rather, it is of a trim, inviting park and a sign welcoming visitors to a friendly town. (Courtesy of William White.)

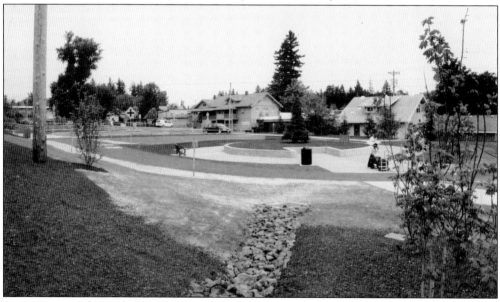

Boring's new park was dedicated in June 2012 and has been enjoyed for civic events ever since; it is also a pleasant area for children to play and adults to spend a quiet afternoon. With its central location across from the venerable Boring-Damascus Grange, it is a natural meeting place. (Courtesy of William White.)

Nine

THE DULL CONNECTION

On a bicycling tour through Oregon, Elizabeth Leighton passed through Boring. On returning to Dull, Perthshire, Scotland, she and her friend Emma Burtles persuaded their women's book club to get in touch with the Boring Planning Organization and investigate the possibility of becoming sister cities. But there were obstacles to the two communities becoming sister cities, chief among them being that neither Dull nor Boring is a city or any officially recognized governmental entity at all. Next, they are of two radically different sizes: Dull has 484 inhabitants in a small area, while Boring stretches out over 13 miles and has more than 8,000 residents. Finally, becoming sister cities is not a casual undertaking, since the requirements are tightly controlled by Sister Cities International.

After much discussion, Boring and Dull decided to call themselves "paired communities" and made official pronouncements to that effect. Newspapers and broadcasters worldwide reported the decision, and a community in Australia—Bland Shire—asked whether it could get into the act. The Dull and Boring pairing, however, was considered a distinctive event that should not be diluted, so it was proposed that a separate organization would be formed: the League of Extraordinary Communities, to include places with names like Boring, Dull, Bland, and Tedious.

In 2013, the Clackamas County Board of Commissioners in Oregon voted to declare August 9 "a Boring and Dull day in perpetuity," and the Boring Grange announced an annual gala event in honor of Boring and Dull Day, with free ice cream and other festivities in the Boring Trailhead Park. Not to be outdone, the State of Oregon signed into law a proclamation of a new state holiday, and the matter was read into the US Congressional Record by Rep. Earl Blumenauer. At the first celebration of Boring and Dull Day in 2013, the news was announced in *Time* magazine and on the front page of the *Wall Street Journal*. In October 2013, a party of eight "Boregonians" traveled to Dull for a weeklong tour of Scotland, ending in a ceilidh with traditional music, dancing, and storytelling at Castle Menzies.

Bessie Stewart was the last of her family to live in the stone house shown in this photograph. She and her brother Robert are two of the children shown. Robert Stewart was best man at the wedding of Thomas Pringle's father. Thomas Pringle is secretary of the Dull and Weem Community Council. (Courtesy of Thomas Pringle.)

In 1886, the Portland Water Committee, predecessor of the Portland Water Bureau, began a search for a superior drinking-water source. Members chose the Bull Run River, and a five-month survey trip led them to conclude that a gravity-flow system could deliver clean water from Bull Run to Portland. Building the reservoir provided employment for people in the area. Some workers had to live on-site in primitive structures.

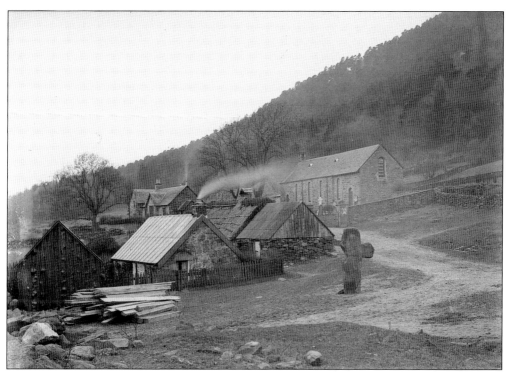

Large trees were not nearly as plentiful in Dull as they were in Boring. With a lack of long-span structural timber, the most common building material for centuries was stone. However, by the beginning of the 20th century, when this photograph was taken, lumber was somewhat more plentiful. (Courtesy of Thomas Pringle.)

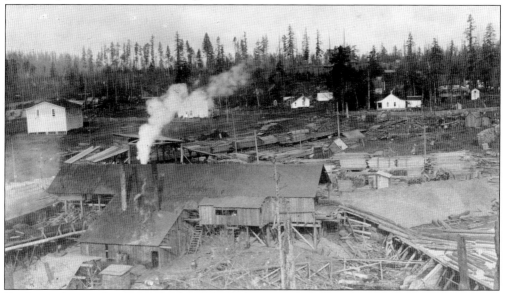

Timber in Oregon, however, was abundant, in some cases, almost a nuisance. Before a homestead could be farmed, it had to be cleared of trees and stumps, a requirement that gave rise to many sawmills in the area. These supplied building materials for nearby Portland, ties for the railroads, and employment for many residents.

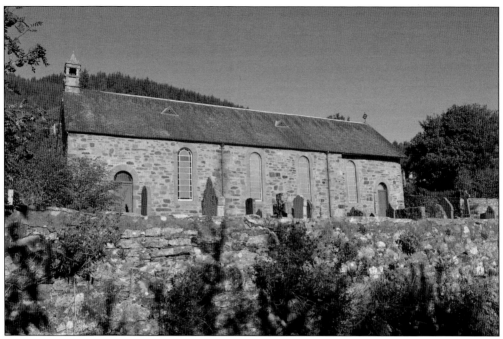

Around AD 704, St. Adamnan, or Eonan, had requested that he be buried "wheresoever the first 'withy' should break." It broke at Dull, and he was laid to rest. A community grew up around the chapel built at his grave, and a monastery and college thrived there. The church has now been adapted for domestic occupation. (Courtesy of Thomas Pringle.)

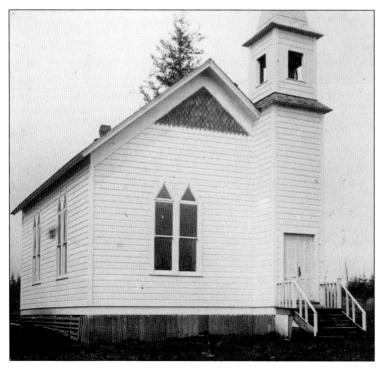

Even though there was "a perfectly good Methodist Episcopal church" in Boring, it was a little too far to travel for some of the outlying neighborhoods, such as Dover. Besides, not everyone had the same denominational preferences, so more than one little church sprang up to meet early settlers' spiritual needs.

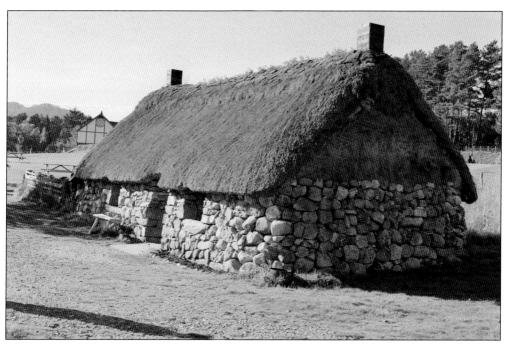

No one can tell for certain whether this building was used as a schoolhouse, but it might have been. The Scottish education system underwent radical change and expansion in the 20th century. The school-leaving age was raised to 14 in 1901, about the time this photograph was taken. (Courtesy of Thomas Pringle.)

In 1883, there was no National Education Association and no teacher's college in Oregon. Often, the teacher in the public school was a young lady who had barely finished school herself, taught for only three months at $25 per month, and boarded with one of the parents. Still, many graduated with a superior education.

It is hereby agreed between the Directors of School District No 19 of Clackamas County Oregon and Carrie Phillips a qualified teacher of said County and State, that the said Carrie Phillips is to teach the public school of said District for the time of Three months for the sum of Seventy five Dollars, (Twenty five Dollars pr Month) commencing on the 30th day of April 1883, and for such services lawfully and properly rendered; the directors of said District are to pay to the said Carrie Phillips the amount that may be due according to this contract; on or before the 20th day of July A.D. 1883

Dated this 30th day of April A.D. 1883

August Diehl Director
Ole Pederson Director
Director
Carrie Phillips Teacher

Sandy Historical Society Photo - 2052

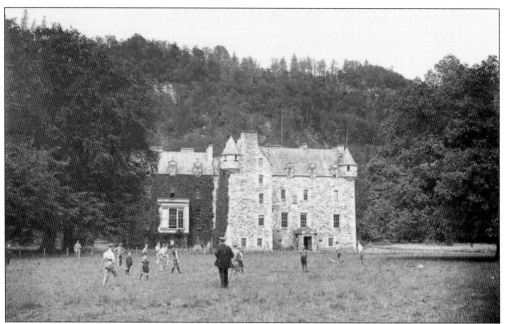

Castle Menzies, ancestral home of Clan Menzies since the 16th century, is halfway between Dull and Aberfeldy. During the second Jacobite rising, the castle hosted Bonnie Prince Charlie, who rested on his way to Culloden in 1746. At the end of their Scottish tour in 2013, visitors from Boring were treated to a ceilidh at the castle. (Courtesy of Thomas Pringle.)

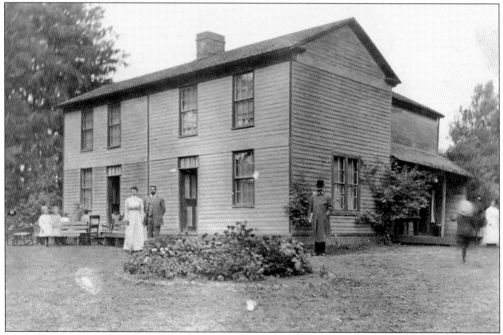

Not nearly as grand as any castle, the home of the Richey family, from whom Richey Road takes its name, was probably the most imposing residence in Boring when this picture was taken around the turn of the century. In 1897, Miles Aubin reported that J.A. Richey was supervising the repair of the Bradley-Richey Road and building an addition to his house.

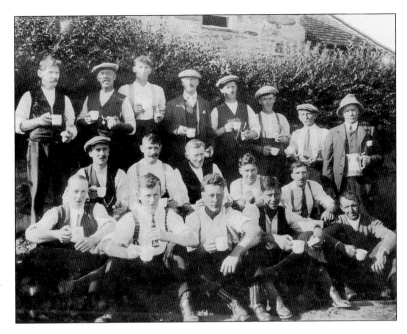

In the 1920s, the men of Dull played quoits, a game roughly equivalent to American horseshoes. Year after year, they played for a silver trophy, which is now in the possession of Thomas Pringle. In the Scottish "long game," the quoits can weigh up to 11 pounds, and the pins can be 18 to 21 yards apart. (Courtesy of Thomas Pringle.)

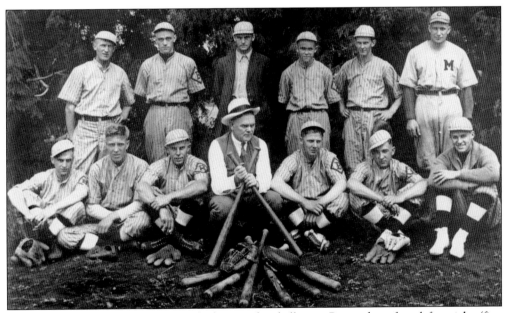

Like every community in 1921, Boring had its own baseball team. Pictured are, from left to right, (first row) Albert Hoffmeister, Allan Burt Compton, Alton Lovelace, Burton Waller (sponsor–Waller's Pool Hall and Confectionery in Boring), Walter Hoffmeister, John Hoffmeister, and unnamed; (second row) Dee Young, ? Amsberg, Otis Rich, Guy Dugger (manager), Lester "Pick" Irvin, and Guy Gribble. The unnamed man at far right is a star pitcher brought from nearby Portland to give the Boring team what some might call an unfair advantage.

Both Dull and Boring have deep roots in agriculture. While touring Scotland on their visit to Dull, Boring visitors were treated to demonstrations of sheep shearing in the old style, without benefit of electric power, as well as the usefulness of border collies in herding sheep. (Courtesy of Stephenie Gross.)

Many annual tasks on the farm were simply too big for one family to handle alone, and the equipment was too expensive to buy for one season's work. If one owned a threshing machine, one could travel from one farm to another all through the harvest season and make pretty good money.

Highland cattle are a Scottish breed with long horns and long, wavy coats developed in the Scottish Highlands and Western Isles of Scotland. A hardy breed, they have been successful in countries where winters are substantially colder than Scotland's. They eat plants that many other cattle avoid. (Courtesy of Stephenie Gross.)

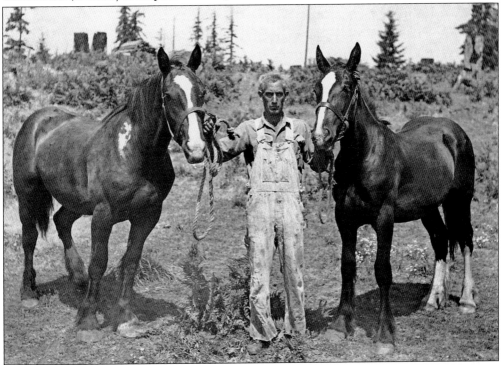

Cattle were important in Boring, too, but before the advent of motorized construction equipment, horsepower was even more so. Here, Homer Revenue—scion of Francis Revenue, who came to Oregon in 1853 and built the first bridge across the Sandy River leading into Clackamas County—displays a pair of his prize horses.

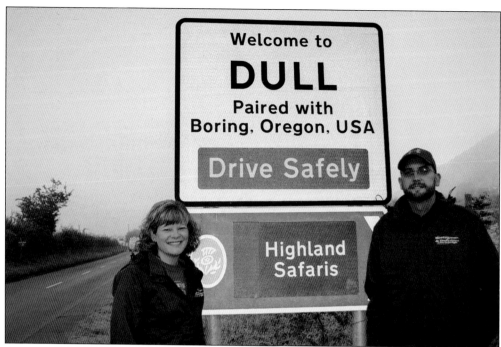

As soon as the twinning of Boring and Dull became official, the Dull and Weem Community Council erected a sign on the road to Dull proclaiming the fact. Stephenie and Nathan Gross, the daughter and son-in-law of Stephen Bates, chairman of the Boring Community Planning Organization, display the sign. (Courtesy of Stephenie Gross.)

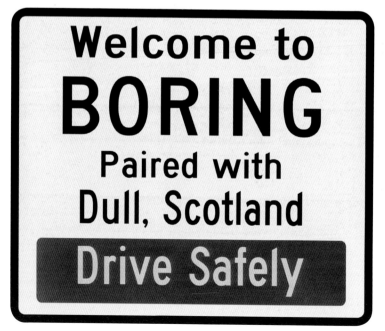

Eager to participate, the Boring Community Planning Organization made arrangements with the Green Food Market in the center of Boring to erect a similar sign. The Chambers Motor Company donated the use of its bucket trucks. Michael Cooper, of the Not So Boring Bar & Grill, and Mark Carroll, of Carroll Signs, did the installation. (Courtesy of Stephen Bates.)

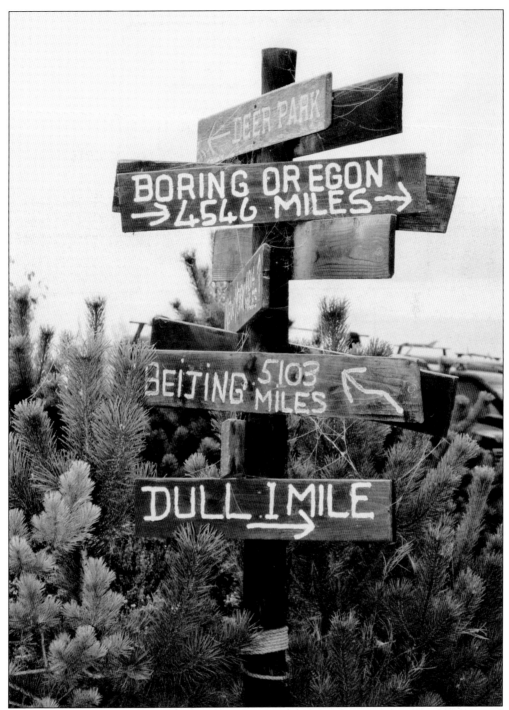

In 1942, while building the Alaska Highway through the Yukon, a homesick soldier erected a sign pointing the way to his hometown 2,226 miles away. Other soldiers served from even farther away, some as many as 10,000 miles from home. Direction signs like these were common during World War II. It did not take long for someone in Dull to put up this one. (Courtesy of Stephenie Gross.)

Miles Aubin, unofficial Boring historian, now deceased, wrote, "This picture demonstrates Thomas Crapper's first principle of plumbing: 'All products in plumbing are influenced by the earth's gravitational pull.' The second principle, not demonstrated in this picture, is 'Payday's on Friday.'"

On May 28, 2013, Oregon governor John Kitzhaber signs House Bill 2352, officially declaring August 9 Boring and Dull Day throughout the state of Oregon. Witnessing the signature are, from left to right, Rep. Jeff Reardon, cosponsor of the bill; Boring resident John Lee; Boring resident Michael Fitz; Rep. Bill Kennemer, sponsor; Boring resident Robert Boring; Sen. Alan Olsen, cosponsor; Boring resident Dan Bosserman; Boring resident Kathryn Bigelow; Boring resident and Community Planning Organization chairman Stephen Bates; Boring resident Norman Rice; Boring resident Laurel Hart (partially hidden from view); unknown Oregon Capitol security staff; Boring resident Judy Gullixson; and Boring resident Betty Bates. (Courtesy of Stephen Bates.)

DISCOVER THOUSANDS OF LOCAL HISTORY BOOKS FEATURING MILLIONS OF VINTAGE IMAGES

Arcadia Publishing, the leading local history publisher in the United States, is committed to making history accessible and meaningful through publishing books that celebrate and preserve the heritage of America's people and places.

Find more books like this at
www.arcadiapublishing.com

Search for your hometown history, your old stomping grounds, and even your favorite sports team.

Consistent with our mission to preserve history on a local level, this book was printed in South Carolina on American-made paper and manufactured entirely in the United States. Products carrying the accredited Forest Stewardship Council (FSC) label are printed on 100 percent FSC-certified paper.

MADE IN THE USA